A short course
in Minolta photography

A short course
in Minolta photography

A guide to great pictures

Barbara London

Curtin & London, Inc.
Somerville, Massachusetts

Van Nostrand Reinhold Company
New York Cincinnati Toronto Melbourne

Printed in the United States of America

Produced in cooperation with Minolta Corporation

Published in 1979 by Curtin & London, Inc.
and Van Nostrand Reinhold Company
A division of Litton Educational Publishing, Inc.
135 West 50th Street, New York, NY 10020, U.S.A.

Van Nostrand Reinhold Limited
1410 Birchmount Road
Scarborough, Ontario M1P 2E7, Canada

Van Nostrand Reinhold Pty. Ltd.
17 Queen Street
Mitcham, Victoria 3132, Australia

Cover design: Harold Pattek

Illustrations: Laszlo Meszoly

Photographs: Donald Dietz and Elizabeth Hamlin, unless otherwise credited

10 9 8 7 6 5 4 3

Library of Congress Cataloging in Publication Data

London, Barbara
 A short course in Minolta photography.

 Bibliography: p. 118
 Includes index.
 1. Minolta camera. 2. Photography—Handbooks,
manuals, etc. I. Title.
[TR263.M47L67 1979] 771.3'1 78-27444
ISBN 0-930764-02-1 (pbk)
 0-930764-12-9

Photo credits

vi (top), Minolta Corp.; vi (bottom), Minolta Corp.; vii (bottom), Bethlehem Steel; 2, Minolta Corp.; 4, Minolta Corp.; 5 (bottom), EPA-Documerica, Fred Ward; 8 (left), Minolta Corp.; 8 (right), Bank Langmore; 9 (top), Courtesy Cambridge School of Ballet; 12, Minolta Corp.; 18, Minolta Corp.; 21, Minolta Corp.; 23, USDA Photo by Charles O'Rear; 25, EPA-Documerica, Dan McCoy; 28 (bottom), EPA-Documerica, Fred Ward; 45, USDA Photo by John Running; 50-55, Minolta Corp.; 57, EPA-Documerica, Bill Strode; 58, Vivitar Corporation; 61 (top), National Park Service, Richard Frear; 61 (bottom), EPA-Documerica, Bill Gillette; 64, Dennis Curtin; 65 (top), EPA-Documerica, Dick Rowan; 67 (top), Peter Laytin; 69 (top), National Park Service, Fred E. Mang, Jr.; 69 (bottom), USDA Photo by Charles O'Rear; 70, EPA-Documerica, Bill Gillette; 80, EPA-Documerica, Fred Ward; 83, EPA-Documerica, Blair Pittman; 84, USDA Photo by Bill Marr; 85 (top), USDA Photo by Charles O'Rear; 85 (bottom), USDA Photo by Michelle Bogre; 101 (top), Bethlehem Steel; 101 (bottom), EPA-Documerica, Dan McCoy; 102, USDA Photo by Duane Dailey; 103 (top), USDA Photo by Byron Schumaker; 104, USDA Photo by John White; 105 (bottom), USDA Photo by Bill Marr; 108 (right), Photo by George Robinson; 110 (top), USDA Photo by Byron Schumaker; 112 (top), Dennis Curtin; 119-134, Minolta Corp.

Cover photograph: Olympic decathlon champion Bruce Jenner; photograph courtesy of Minolta Corporation.

Preface

Camera controls—f-stops, shutter speeds, focal length of lenses, focusing—can initially appear to be very complicated. But if you have just bought or are contemplating the purchase of a Minolta 35mm single-lens reflex camera, all that you need to know to begin taking good pictures can be learned in a weekend and probably on a Saturday afternoon. The key is that the basic principles that take this short amount of time to learn have an almost infinite variety of combinations and it is those combinations that make photography both interesting and an avocation with a lifetime of possible growth.

Photography isn't as difficult as it used to be. The innovations in equipment make it much easier to get good exposures in all kinds of lighting situations. The Minolta's innovative use of new materials and electronic technology, particularly computer circuitry, have made possible a new generation of cameras — simple to operate, compact, and versatile. Today, you can master the basics much faster, so you can concentrate on what is important...the image.

This book covers the basic principles of photography, the ones that must be understood to take full advantage of the creative controls on the camera you use. Essentially you need to know how to obtain a good exposure and how to use focus, aperture (the size of the lens opening), and shutter speed to create the picture you want. These basic principles are stressed and presented completely. In addition, the book covers film, flash, exposure meters, accessory equipment, and other important information.

The book is designed so that every two facing pages completes a fundamental idea. This format permits you to use the book as a reference and to learn about specific topics as the need arises. The book is heavily illustrated with photographs and line art so that it can be understood more easily and quickly.

There is no doubt that greater satisfaction comes from using the camera as a creative tool and it is toward that end that this book will lead.

Contents

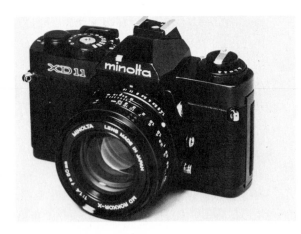
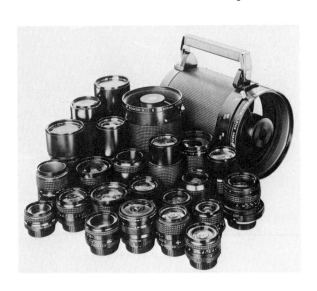

chapter 3 **Film and exposure** **38**

chapter 4 **Color** **58**

chapter **5** **Special techniques** **70**

chapter **6** **Lighting** **82**

chapter 7 **How to see like a camera 94**

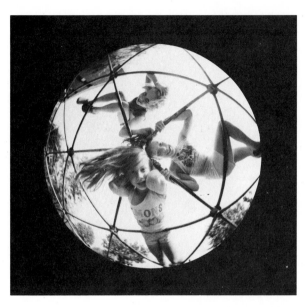

1 The Minolta camera

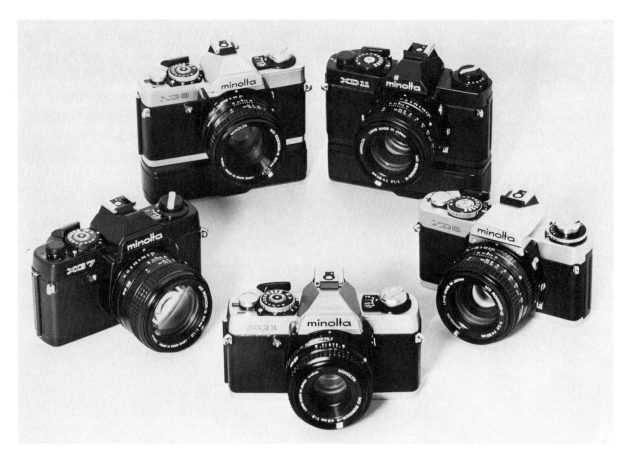

If you have progressed beyond the stage of simply wanting to take ordinary snapshots, then a Minolta 35mm single-lens reflex (SLR) is an excellent camera for you to use. It is small enough to carry almost anywhere yet uses large enough film to produce good quality prints and slides. The special features and great flexibility of Minolta SLRs make them popular with professional photographers, with people who are seriously interested in photography, and with those who like to take pictures just for the fun of it.

Through-the-lens viewing. A single-lens reflex uses the same lens both for viewing the scene and for exposing the film, so what you see in the camera's finder is a good indication of what you'll get in the final picture. With a built-in exposure meter you can measure the brightness of the scene directly through the lens in order to determine how much to expose the film. And you can do this while looking at the exact area or object that is being metered (measured for brightness).

Automation. In just the last few years a revolution has occurred in camera design. One of the major controls in picture making—exposure—can be tak-

en over by tiny silicon chips and other components built into the camera. This electronic circuitry measures the light and then lets in just enough to expose the film properly. In some cases you will want to (and can) override the decision of these automatic calculators, but in many situations they will expose your picture so well that all you have to do is focus and shoot.

Compact size. When you hold a Minolta 35mm single-lens reflex camera in your hands, it feels comfortable—compact in size and convenient to carry with you. SLRs are getting even smaller and lighter as electronic circuitry replaces the maze of springs and gears that used to power shutters and other mechanisms.

Versatility. When you buy a Minolta SLR, you are buying a system, not just a camera. Lenses are interchangeable and certain other parts are as well. Options like automatic flash units and motor-driven film advance are available.

This book tells about Minolta SLRs and how you can use their special features to make the pictures you want.

Below: (A) pocket camera; (B) 35mm range finder; (C) 35mm single-lens reflex; (D) twin lens reflex; (E) large format single-lens reflex; (F) 4 x 5 view camera

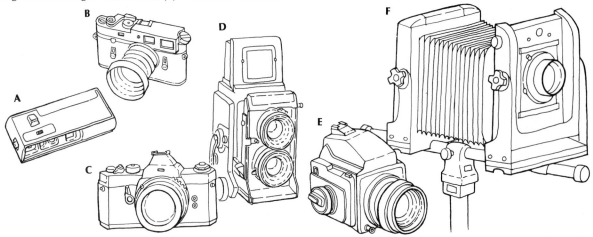

Using your Minolta's basic creative controls

Cameras don't quite "see" the way the human eye does, and so at first the pictures you get may not be the ones you expected. One of the features of this book is to give you control over the picture-making process by showing you how to see more the way the camera does and how to use the camera's controls to make the kind of pictures you want.

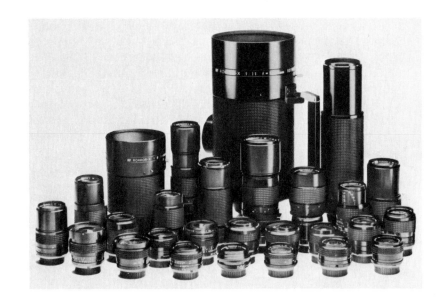

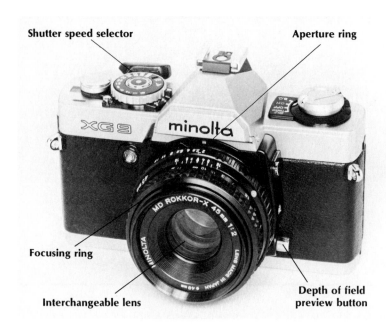

Shutter speed selector

Aperture ring

Focusing ring

Interchangeable lens

Depth of field preview button

Interchangeable lenses. *With a single-lens reflex you can make a picture with a lens of normal focal length—a lens that views a scene just about as you do. Or, since you can carry several lenses with you and change them as you wish, you can get very different pictures of the same scene—a greatly enlarged image of a distant object, for example. See pages 20–27 for more about focal lengths and the effects they produce.*

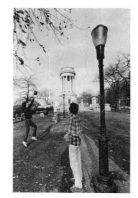

Shutter speed control. *Objects that are moving can be shown dead sharp and frozen in midmotion or blurred, either a little bit or a lot. Turn to pages 10–11 and 14–15 for information about shutter speeds, motion, and blur.*

 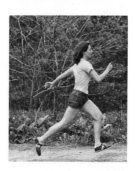

Aperture control. *Do you want part of the picture sharp and part out of focus, or do you want the whole picture sharp from foreground to background? Changing the size of the aperture (the lens opening) is one way to control this depth of field. Your camera may have a button that lets you preview the depth of field in the final picture. More about aperture on pages 12–15.*

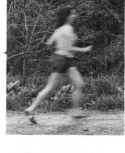

Focusing. *Through the viewfinder window you see the scene that will be exposed on the film, including the particular part of the scene the camera is focusing on. The image is focused sharply by turning the focusing ring on the lens. More about focusing and sharpness appears on pages 12–15 and 30–33.*

Inside a 35mm single-lens reflex

The lightweight, compact body of a modern single-lens reflex camera is sleek and functional. If you could cut away the shell of your SLR you'd find packed inside thousands of precisely engineered mechanical and electronic parts. All of them are there to help you take better pictures—by making the camera easy to operate, critically accurate in focusing and other controls, plus rugged enough to be reliable day after day. Opposite is a simplified look inside a single-lens reflex (designs vary in different models). The camera takes its name from its single lens (some reflex cameras have two lenses) and from its reflection of light upwards for viewing the image.

A single-lens reflex cut open (opposite)

A. Body. *The light-tight box that contains the camera's mechanisms and protects the film from light until you are ready to make an exposure.*

B. Lens. *Focuses an image on the film. Single-lens reflex lenses are interchangeable.*

C. Lens elements. *The optical glass lens components that produce the image.*

D. Focusing ring. *Turning the ring focuses the image by adjusting the distance of the lens elements from the film plane.*

E. Iris diaphragm. *A circle of overlapping leaves that open up to increase (or close down to decrease) the amount of light reaching the film.*

F. Aperture ring. *Turning the ring adjusts the size of the iris diaphragm inside the lens.*

G. Mirror. *During viewing, the mirror reflects light from the lens upwards onto the viewing screen.*

H. Viewing screen. *A ground-glass (or similar) surface onto which the focused image appears upside down and backwards. Some SLR cameras have interchangeable viewing screens with cross lines or other features.*

I. Pentaprism. *A five-sided optical device that reflects the image from the viewing screen until it appears right side up and correct from left to right. On some cameras the pentaprism can be* replaced with a specialized viewfinder such as a waist-level finder.

J. Viewfinder eyepiece. *A window in which the corrected image from the pentaprism is visible to the photographer.*

K. Shutter. *During an exposure, the mirror first swings upwards out of the way so the light passes straight ahead. Then the shutter opens to expose the film to the light. The action of the shutter is diagrammed opposite at top.*

L. Film. *The light-sensitive material that records the image.*

M. Film advance lever. *Advances an unexposed segment of film behind the shutter in preparation for exposure.*

N. Shutter speed dial. *Selects the shutter speed or in some models the mode of automatic operation.*

O. Shutter release. *Activates the exposure sequence in which the mirror raises, the shutter opens, and the film is exposed.*

P. Hot shoe. *Attaches a flash unit to the camera and with suitable units provides the electrical linking that synchronizes the camera and the flash.*

Q. Rewind crank. *Rewinds the film into its cassette after the roll of film has been exposed.*

R. Film cassette. *The light-tight container in which 35mm film is packaged.*

The shutter of a single-lens reflex camera is located just in front of the film (at K in the camera diagram). During exposure the shutter opens to form a slit that moves across the film. The size of the slit is adjustable; the wider the slit, the longer the exposure time and the more light that reaches the film. Shown above is a shutter that travels horizontally across the film. Some shutters travel vertically.

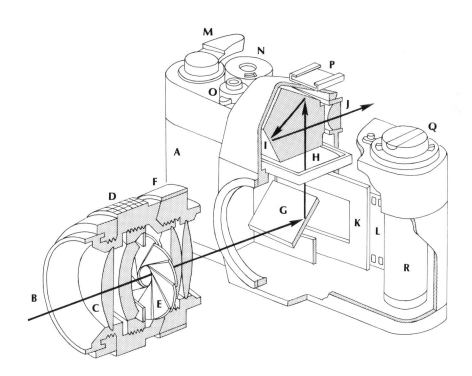

Minolta electronics

As cameras become more complex internally, incorporating sophisticated computing modules and other electronic devices, they are actually becoming *less* complicated for the photographer to use.

You have a choice of exposure modes with Minolta cameras. The XD-11 (below and page 121) and the XD-5 (page 120) offer three modes: aperture priority, shutter priority, and metered manual. In aperture priority mode, you set the lens opening and the camera automatically sets the shutter speed. This mode is useful when you want to control the depth of field or sharpness of the image, because the size of the lens opening is a major factor affecting sharpness.

In shutter priority mode, you set the shutter speed and the camera automatically sets the correct aperture. If your lens reaches its widest (or smallest) opening and there is still not enough (or too much) light, the camera automatically makes the necessary change in the shutter speed so that correct exposure is assured, a feature found only on Minolta XD multi-mode cameras. Shutter priority operation is useful when stopping motion is important, as at sporting events, because the shutter speed determines whether moving objects will be sharp or blurred.

Metered manual operation is your third choice with the XD-11. You set both the lens opening and shutter speed yourself, using, if you wish, the camera's built-in light meter to measure the brightness of the light. But, even in automatic operation you have flexibility in exposure choices. For example, in aperture priority operation, you can change the shutter speed too; you can shoot at a faster shutter speed by opening the aperture wider, or at a slower speed by making the aperture smaller. The aperture is similarly adjustable when you are in shutter priority operation.

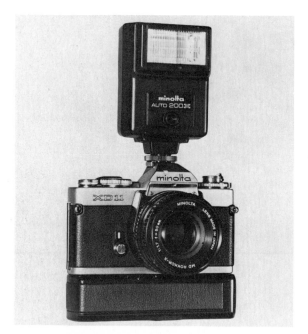

The Minolta XD-11 *compact automatic, 35mm single-lens reflex camera with Auto Electroflash 200X and Auto Winder D. (The XD-11 is known as the XD-7 or XD in certain market areas.)*

The XD-11's viewfinder *makes sure you never lose sight of your subject to make exposure adjustments. It shows the pre-selected shutter speed and/or aperture. Light-emitting diode (LED) readouts show shutter speed or aperture changes that are being set automatically. LED displays also show you when the flash is ready to fire and give you warnings of under- or overexposure.*

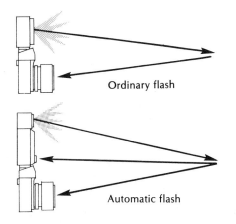

Ordinary flash

Automatic flash

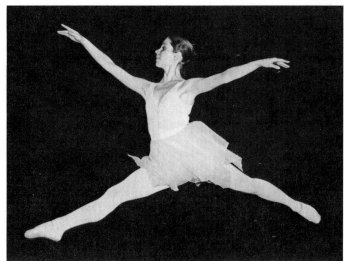

For flash pictures *the Auto Electroflash 200X auto-matically sets the XD-11's shutter to the correct speed for flash synchronization. A sensor on the flash reads the light reflected back from the subject and cuts off the flash at the proper exposure. The flash has high and low power automatic and manual settings. In the manual low power position, recycling time is fast enough to match the 2-frames-per-second advance speed of the Auto Winder D.*

Motorized film advance *exposes the film and winds it forward with one push of a button. The auto winder shown opposite can capture sequences of photo-graphs at speeds of up to about 2 frames per second or expose film a single frame at a time.*

Shutter speed: Affects light and motion

Light and the shutter speed. The shutter is one control of the amount of light that strikes the film. (The aperture, page 12, is the other.) The shutter speed dial on the camera sets the shutter so it remains open for a given fraction of a second after the shutter release is pressed (see illustration below). The B or bulb setting keeps the shutter open as long as the shutter release is held down.

Motion and the shutter speed. In addition to controlling the amount of light that enters the camera, the shutter speed also affects the way that moving objects are shown. A fast shutter speed can freeze motion—from a ballet leap to a falling drop of water. A slow shutter speed keeps the lens open long enough for the image to blur. The important factor is how much the image actually moves across the film. The more of the film it crosses while the shutter is open, the more the image will be blurred. How fast a shutter speed is needed to freeze motion depends in part on the direction the subject is moving in relation to the camera (see opposite).

The focal length of the lens and the distance of the subject from the camera also affect the size of the image on the film and thus how much it will blur. A subject can appear small if it is photographed with a short-focal-length lens or if it is far from the camera, and so it may move relatively far before its image crosses enough of the film to cause blur.

Obviously, the speed of the motion is also important, and, all other things being equal, a darting swallow needs a faster shutter speed than a hovering hawk. Even fast-moving subjects, however, may have a peak in their movement where the motion slows just before it reverses. A gymnast at the height of a jump, for instance, or a motorcycle on a sharp curve are moving slower than at other times and so can be sharply photographed at relatively slow shutter speeds.

Blurring to show motion. Freezing a motion is one way of representing it, but not the only way. In fact, freezing a motion sometimes eliminates movement altogether so that the subject seems to be at rest. Allowing the subject to blur can be a graphic means of showing that it is moving.

Panning to show motion. Panning the camera—moving it in the same direction as the subject's movement during the exposure—is another way of showing motion (opposite, bottom right). The subject will appear sharper than if the camera were held steady, while the background will be blurred.

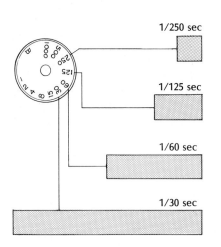

1/250 sec

1/125 sec

1/60 sec

1/30 sec

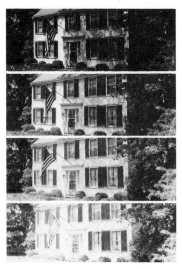

Shutter speed settings *are typically in seconds: 1 sec, 1/2 sec, 1/4, 1/8, 1/15, 1/30, 1/60, 1/125, 1/250, 1/500, 1/1000 and sometimes 1/2000. Only the bottom part of the fraction appears on the shutter speed dial and in any exposure information displayed in the viewfinder. Each setting lets in twice as much light as the next setting (or half as much as the previous setting): 1/60 sec lets in twice as much light as l/125 sec, half as much as 1/30 sec.*

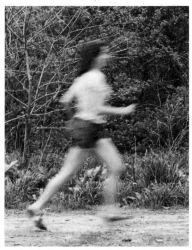

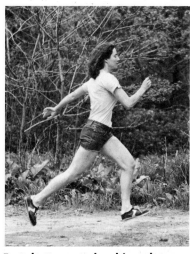

1/30 sec

Slow shutter speed, subject blurred.
The direction a subject is moving in relation to the camera can affect the sharpness of the picture. At a slow shutter speed, a jogger moving from left to right is not sharp.

1/125 sec

Fast shutter speed, subject sharp.
Photographed at a faster shutter speed, the same jogger moving in the same direction is sharp. During the shorter exposure her image did not cross enough of the film to cause blur.

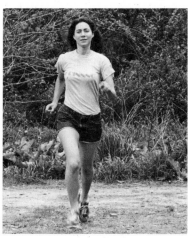

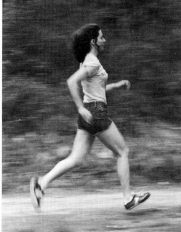

1/30 sec

Slow shutter speed, subject sharp.
Here the jogger is sharp even though photographed at the slow shutter speed that recorded blur in the first picture. Because she was moving directly toward the camera her image did not cross enough of the film to blur.

1/30 sec

Panning *with the jogger is another way to keep her relatively sharp. During the exposure the photographer moved the camera in the same direction that the jogger was moving.*

11

Aperture: Affects light and depth of field

Light and the aperture. The aperture, or lens opening, is another control that you can use in addition to shutter speed to adjust the brightness of the light that reaches the film. Turning a ring on the outside of the lens changes the size of the aperture diaphragm, a ring of overlapping metal leaves inside the lens. Like the iris of your eye, the diaphragm can get larger (open up) to let more light in; it can get smaller (stop down) to decrease the amount of light.

Aperture settings (f-stops). These are: f/1 (theoretically the widest opening), f/1.4, f/2, f/2.8, f/4, f/5.6, f/8, f/11, f/16, f/22, f/32, f/45. F-stops smaller than f/45 are seldom found. Each aperture setting lets in double the light as the next setting up the scale (or half the light of the next setting down the scale). The relationship is not as obvious from the sequence of f-stop numbers as it is with shutter speeds (which also have a half-or-double relationship: 1 second, ½ second, ¼ second, and so on), but after a while the f-stops become just as familiar and easy to remember. No lens has the entire range of f-settings. A 50mm lens may range from f/2 to f/16, a 200mm lens from f/4 to f/22.

One irregularity sometimes occurs: the widest f-stop may be slightly less or more than one full stop from the next setting. For example, a lens may open to f/3.5, then go to the regular sequence of f/4, f/5.6, and so on.

Depth of field and the aperture. The size of the aperture setting also affects the relative sharpness of objects in the image, known as depth of field. In theory, only one distance from the lens, the plane of critical focus, can be acutely focused at one time. However, in practice, part of the scene near the plane of critical focus also appears acceptably sharp. As the aperture opening gets smaller, the depth of field increases and more of the scene appears sharp in the print. (More about depth of field on pages 30–33.)

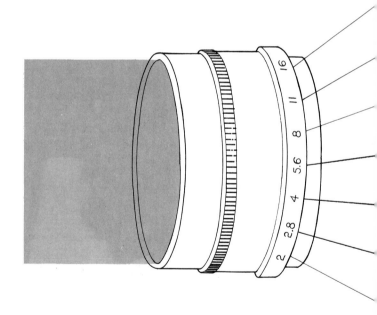

Light and the aperture. *The size of the lens opening—the aperture—controls the amount of light that passes through the lens. Each f-setting is one "stop" from the next, that is, each lets in twice the light of the next smaller setting, half the light of the next larger setting. Notice that the smaller the lens opening, the larger the numeral. F/22 is a smaller opening than f/16, which is smaller than f/11, and so on.*

Aperture affects amount of light

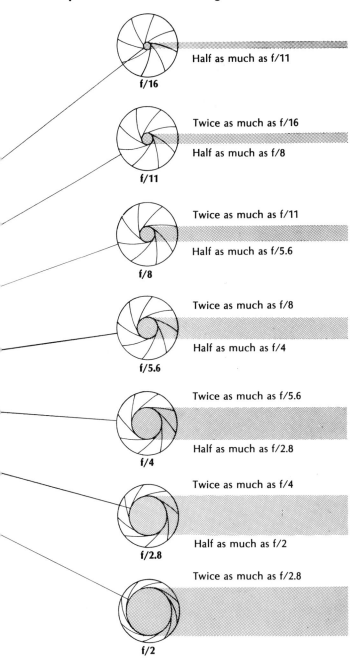

f/16 — Half as much as f/11

f/11 — Twice as much as f/16 / Half as much as f/8

f/8 — Twice as much as f/11 / Half as much as f/5.6

f/5.6 — Twice as much as f/8 / Half as much as f/4

f/4 — Twice as much as f/5.6 / Half as much as f/2.8

f/2.8 — Twice as much as f/4 / Half as much as f/2

f/2 — Twice as much as f/2.8

Aperture affects depth of field

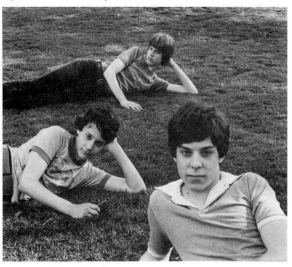

Depth of field and the aperture. *The larger the aperture opening, the less the depth of field. At f/16 (above) the entire depth in the scene from foreground to background was sharp. At a much larger aperture, f/2 (below), the depth of field decreased considerably: the photographer focused on the middle boy and the only other acceptably sharp areas were just a little nearer to the camera from the boy and just a little farther away.*

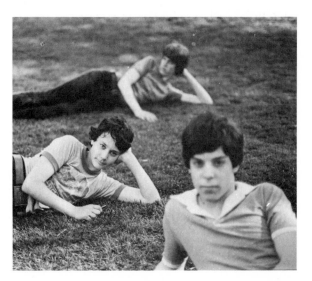

Shutter speed and aperture: Blur vs. depth of field

Controlling the amount of light. There are two controls of the amount of light striking the film: shutter speed (length of exposure) and aperture (brightness of light). Either one can be used to increase or decrease the amount of light.

Each f-stop setting lets in half (or double) the light of the adjoining setting. Each shutter speed setting does the same. A move to the next setting changes the exposure by one stop. Correct exposure can be obtained from any combination of f-stop and shutter speed settings that lets in the proper amount of light. The exposure stays constant if, for example, a move to the next faster shutter speed (minus one stop exposure) is matched by a move to the next larger aperture (plus one stop exposure).

Other effects on the image. But since the shutter speed also affects the way motion is shown and the size of the aperture also affects the overall sharpness of the photograph (its depth of field), you can decide for each picture whether stopped motion or depth of field is more important. More depth of field (with a small aperture) means more possibility of blur (with a slow shutter speed) and vice versa. Depending on the situation, you may have to compromise on a moderate amount of depth of field with some possibility of blur.

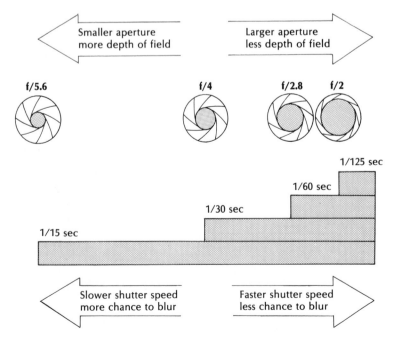

Smaller aperture more depth of field

Larger aperture less depth of field

f/5.6 f/4 f/2.8 f/2

1/125 sec

1/60 sec

1/30 sec

1/15 sec

Slower shutter speed more chance to blur

Faster shutter speed less chance to blur

Shutter speed and aperture combinations. *Both the shutter speed and the aperture size control the amount of light that strikes the film. Each setting lets in half (or double) the amount of light of the adjacent setting. Changing from one setting to the next changes the exposure by one stop, so if you decrease the amount of light one stop by moving to the next smaller f-stop setting, you can keep the exposure constant by also moving to the next slower shutter speed. Each combination of f-stop and shutter speed shown lets in the same amount of light, but, as illustrated at right, different f-settings and shutter speeds change the depth of field and appearance of motion in the picture.*

Shutter speed and aperture combinations. *Each of the combinations for the scene at right let in the same total amount of light, so the overall exposure stayed the same. But the children on the swings are less or more blurred depending on whether a fast or slow shutter speed was used. And the depth of field (overall sharpness of nonmoving objects) is greater or smaller depending on whether a small or large aperture was used. One picture is not necessarily better than another—the choice is up to the photographer.*

Very fast shutter speed *(1/1000 sec): the children are frozen in mid-swing.* **Very wide aperture** *(f/2): the lawn in the middle distance and the trees in the background are definitely out of focus.*

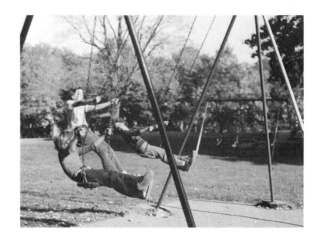

Medium-fast shutter speed *(1/125 sec): the children are slightly blurred.* **Medium-wide aperture** *(f/5.6): the grass and trees are noticeably sharper than above.*

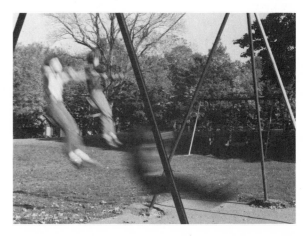

Slow shutter speed *(1/15 sec): the children are very blurred because of their motion during the exposure.* **Small aperture** *(f/16): the trees are distinctly sharp; compare the branches and leaves in each of the pictures.*

Care of camera and lens

Cameras are remarkably sturdy instruments considering the precision mechanisms that they contain, but a reasonable amount of care in handling and maintaining the camera will more than repay you with longer trouble-free life and better performance.

To protect a camera in use, a neck strap, either around your neck or wound around your wrist, keeps the camera handy and makes it less likely to be dropped. Ever-ready cases enclose the camera and have a front that folds down for picture taking. They provide protection but may be tedious to take off and put on. Gadget bags are good for carrying a few items. Lenses can be kept in plastic bags to protect them from dust, with lens caps both back and front for additional protection of lens surfaces. Aluminum cases with fitted foam compartments provide the best protection against jolts and jars; their disadvantage is that they are not conveniently carried on a shoulder strap. In a high-theft area, some photographers prefer a case that doesn't look like a camera case—for example, a sports bag or a small backpack. A beat-up case that looks as though it contains sneakers and a sweatsuit is less likely to be stolen than one that shouts "Cameras."

Cameras in transit should be protected from excessive heat; for example, avoid the interior of a glove compartment on a hot day. At very low temperatures, meter batteries and other mechanisms may be sluggish, so it is a good idea to carry the camera under your coat until ready to expose. On the beach, protection from salt spray and sand is vital. Modern electronic cameras have many electrical contacts, and corrosion can cause serious malfunctions. Accidental immersion in salt water can occur, however. You might have a chance of salvaging the camera if you immediately and thoroughly rinse the salt water away with fresh water, then take the camera to a repair shop as soon as possible. Your only consolation is that you are not the first one to have this happen.

If the camera will not be used for a while, release the shutter, turn off the exposure meter, and store the camera away from excessive heat, humidity, and dust. Avoid storage near radios, televisions, or magnets, which can put out magnetic fields that can damage certain automatic exposure systems. Operate the shutter occasionally, because it may become balky if not used. For long-term storage, remove batteries, since they occasionally corrode and leak.

Cleaning inside the camera. *When you blow or dust inside the camera, tip the camera so the dust falls out and isn't pushed farther into the mechanism. Do not touch the delicate shutter curtain unless absolutely necessary.*

Cleaning the lens. *First, blow or brush any visible dust off the lens surface. Holding the lens upside down helps the dust fall off the surface instead of just circulating on it.*

Using lens cleaning fluid. *Dampen a wadded piece of tissue with the fluid and gently wipe the lens in a circular direction. Don't put lens fluid directly on the lens since it can run to the edge and soak into the barrel. Finish with a gentle, circular wipe with a dry wad of tissue.*

Protecting a camera from dust and dirt is the prime concern of ordinary camera care. Load and unload film or change lenses in a dust-free place if you possibly can. When changing film, blow or brush around the camera's film-winding mechanism and along the film path. This will remove dust as well as tiny bits of film that can break off and work into the camera's mechanisms. Be careful of the shutter curtain when doing this, since it is delicate and should be touched only with extreme care—preferably not touched at all. You may want to blow occasional dust off the focusing mirror or screen, but beyond this a competent camera technician should do any work on the interior of the camera.

The lens surface must be clean for best performance, but keeping dirt off of it in the first place is much better than too-frequent cleaning, which can damage the delicate lens coating. Particularly avoid touching the lens surface with your fingers, because they can leave oily prints that may corrode the coating. Keep a lens cap on the front of the lens when it is not in use and on the back of the lens as well if the lens is removed from the camera. During use, a lens hood helps protect the lens surface in addition to shielding the lens from stray light that can flare and fog the image.

To clean the lens you will need a soft rubber squeeze bulb, like an ear syringe, a soft brush, lens tissue, and lens cleaning fluid. Avoid any eyeglass cleaning product; they are too harsh for lens surfaces. Shirttails, a clean handkerchief, or paper tissues are usable in an emergency, but lens tissue is much better.

2 The Minolta lens

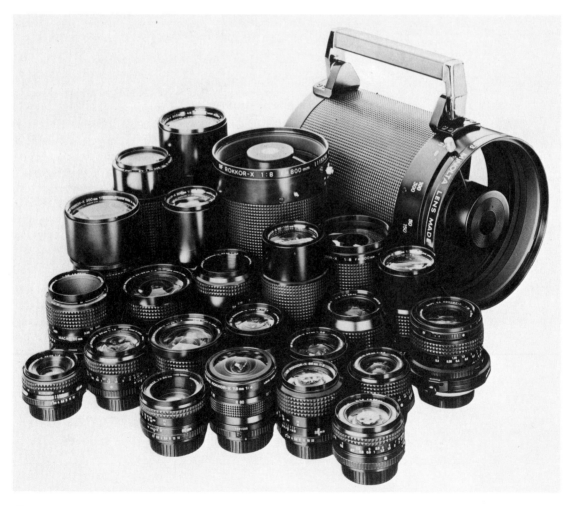

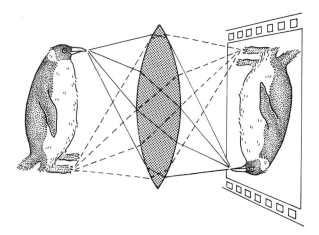

A simple lens *forms an image of an object, but because of inherent defects or aberrations in this type of lens, the image is subject to various distortions and is not very sharp.*

A modern compound lens *combines several lenses ground to different specifications that largely cancel out each other's defects. In recent years Minolta designers, aided by computers, have produced a great variety of new lenses with improved image sharpness and lens speed.*

Forming an image. Although a good lens is essential for making crisp, sharp photographs, you don't actually need one to take pictures. A primitive camera can be constructed from little more than a shoebox with a small pinhole at one end and a piece of film at the other. A pinhole won't do as well as a lens, but it does form an image of objects in front of it.

A simple lens, as in a magnifying glass, will also form an image—one that is brighter and sharper than that from a pinhole. But a simple lens has many optical defects or aberrations that prevent it from forming an image that is sharp and accurate. A modern compound lens eliminates these aberrations by combining several lens elements ground to different thicknesses and curvatures so that in effect they cancel out each other's aberrations.

Lens speed. The main function of lenses is to project a sharp image onto the film, but, in addition, lenses vary in design, with different types made to perform some jobs better than others. The two major differences are in speed and focal length. Lens speed is not the same as shutter speed; it is rather the widest aperture to which the lens diaphragm can be opened. A lens that is faster than another opens to a wider aperture and admits more light; it can be used in dimmer light or at a faster shutter speed.

Lens focal length. An even more important lens characteristic is focal length. One of the advantages of a Minolta camera is the interchangeability of its lenses; the reason photographers own more than one lens is so that they can change lens focal length. More about focal length appears on the following pages.

Lens focal length: The basic difference between lenses

Photographers generally describe lenses in terms of their focal length; they refer to a normal, long, or short lens, a 100mm lens, a 6″ lens, and so on. Focal length affects the image formed on the film in two important and related ways: the amount of the scene shown (the angle of view) and thus the size of objects (their magnification).

How focal length affects an image. The shorter the focal length of a lens, the more of a scene the lens takes in and the smaller it makes each object in the scene appear in the image. You can demonstrate this by looking through a circle formed by your thumb and forefinger. The shorter the distance between your hand (the lens) and your eye (the film), the more of the scene you will see (greater angle of view), and since more objects will be shown on the same size negative, the smaller all of them will have to be (less magnification). This is similar to filling a negative with an image of one person's head or with a group of 20 people. In the group portrait, each person's head is smaller.

Interchangeable lenses are convenient. The amount of the scene shown and the size of objects can also be changed by moving the camera closer to or farther from the subject, but the additional option of changing lens focal length gives you much more flexibility and control. Sometimes it is impossible to get closer to your subject, such as a boat on a lake, if you are standing on shore. Sometimes it is difficult to get far enough away, as when you are photographing a large group of people in a small room.

With a single-lens reflex you can remove one lens and put on another when you want to change focal length. Interchangeable lenses range from super-wide-angle fisheye lenses to extra-long telephotos. A zoom lens is a single lens with adjustable focal lengths.

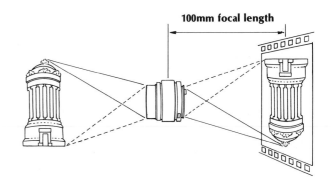

100mm focal length

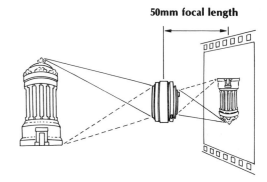

50mm focal length

Focal length *is measured from the optical center of a lens to the image it forms on the film. It is measured when the lens is sharply focused on an object in the far distance (technically known as infinity). Magnification, the size of an object in an image, is one important characteristic that is affected by focal length. As the focal length increases, the size of the object increases. A 100mm lens produces an image exactly twice as large as a 50mm lens will.*

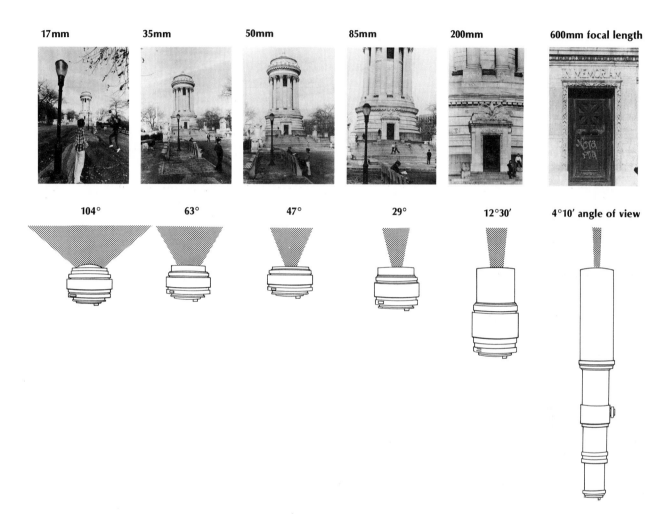

17mm	35mm	50mm	85mm	200mm	600mm focal length
104°	63°	47°	29°	12°30′	4°10′ angle of view

What happens when you change lens focal length?

With a given size of film, the amount of a scene included in the image (angle of view) and the size of objects (magnification) are changed if the focal length of the lens is changed. To make this sequence, the photographer changed only the focal length of the lenses, while the distance from lens to subject remained the same. As the focal length got longer, for example, from 17mm to 35mm, the angle of view narrowed and the size of objects increased.

Normal focal length: The most like human vision

In photography, as in other matters, *normal* implies that something is similar to the way most people do or see things. A lens of normal focal length, as you might expect, produces an image on film that seems normal when compared with human vision. The image includes about the same angle of view as the human eye sees clearly, and the relative size and spacing of near and far objects appear normal. For 35mm cameras, this effect is produced by a lens of about 50mm focal length, and 35mm cameras typically are fitted by the manufacturer with a lens of this type. The size of the film used in a particular camera determines what focal length is normal for that camera; cameras that use film sizes larger than 35 mm have proportionately longer focal lengths for their normal lenses.

Normal lenses have many advantages. Compared to those of shorter or longer focal length, normal lenses are generally faster: they can be designed with wider maximum apertures to admit the maximum amount of light. Therefore, they are the most suitable lenses for low light levels, especially where action is involved, as in theatre or indoor sports scenes or in low light levels outdoors. They are a good choice if the camera is to be hand held since a wide maximum aperture permits a shutter speed fast enough to eliminate lens movement during exposure. Generally, the normal lens is more compact and lighter in weight, as well as somewhat less expensive, than comparable lenses of longer or shorter focal length.

Normal focal length can vary. The "normal" focal length used by a particular photographer—the focal length lens usually fitted on his or her camera—is a matter of personal preference. Many photographers use a lens with a focal length of 35 mm as their normal lens because they like its wider view and greater depth of field. Some use an 85mm lens because they prefer its narrower view, which can concentrate the image on the central objects of interest in the scene.

A lens of normal focal length produces an image that appears similar to that of normal human vision. The amount of the scene included in the image and the relative size and placement of near and far objects are what you would expect to see if you were standing by the camera. The scene does not appear exaggerated in depth, as it might with a short-focal-length lens, nor do the objects seem compressed and too close together, as sometimes happens with a long-focal-length lens.

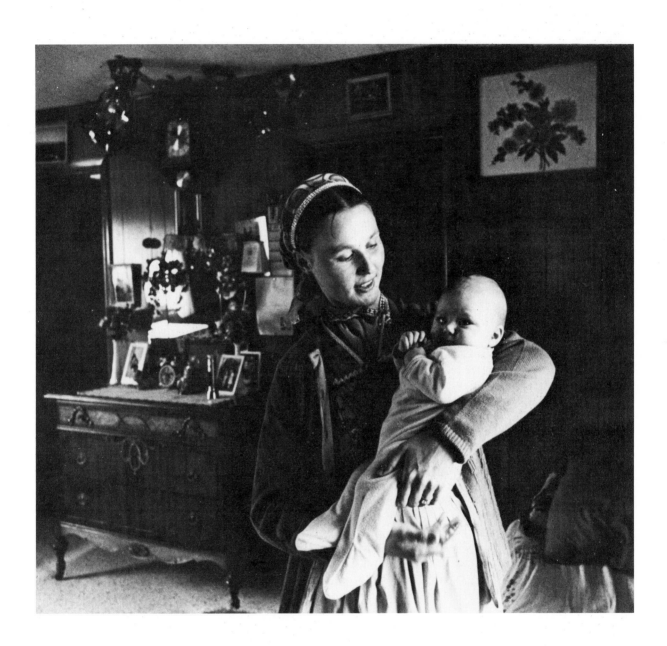

Long focal length: Telephoto lenses

A lens of long focal length seems to bring things closer, just as a telescope does. As the focal length gets longer, less of the scene is shown (the angle of view narrows), but what is shown is enlarged (the magnification increases). This is useful when you are so far from the subject that a lens of normal focal length produces an image that is too small. Sometimes you can't get really close—at a sports event, for example—sometimes it is better to stay at a distance, as in nature photography. An intercepted pass, the President descending from Air Force One, and an erupting volcano are all possible subjects for which you might want a long lens.

A long lens has relatively little depth of field. When you use long lenses, you'll also notice that as the focal length gets longer, depth of field decreases so that less of the scene is in focus at any given f-stop. For example, at the same distance from the subject, a 200mm lens at f/8 has less depth of field than does a 100mm lens at f/8. Sometimes this is inconvenient, but it also can work to your advantage by permitting unimportant details or a busy background to be photographed out of focus and thus visually eliminated.

A long lens, compared to one of normal focal length, is larger, heavier, and somewhat more expensive. Its largest aperture is relatively small; f/4 or f/5.6 is not uncommon. It must be focused carefully because with its shallow depth of field there will be a distinct difference between objects that are sharply focused and those that are not. A faster shutter speed is needed to hand hold because the enlarged image magnifies even a slight movement of the lens during exposure. All these disadvantages increase as the focal length increases, but so do the long lens's unique image-forming characteristics.

Portrait with medium-long lens. *A medium-long lens of 85–135 mm is particularly useful for portraits because the photographer can be relatively far from the subject and still fill the image frame. Many people feel more at ease when photographed if the camera is not too close, and a moderate distance between camera and subject eliminates the distortion of perspective that occurs when a lens is used very close. A good working distance would be 2–2.5 m (6–8 ft).*

Portrait with shorter lens. *To get a head-and-shoulders image of this same subject with a lens of normal focal length (50 mm), the photographer had to move in close. Photographing a person from very close makes the size of the features nearest to the camera unnaturally large and sometimes even grotesque. If this same lens were used farther back, the subject's head would be small, perhaps too small to enlarge to the desired size without loss of quality.*

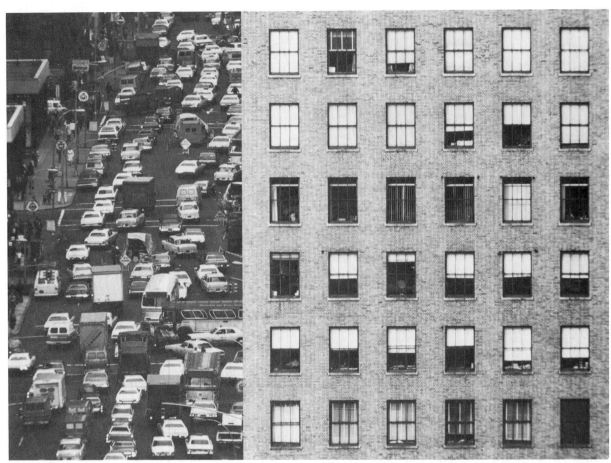

A long lens can seem to compress space. *Though traffic was heavy in New York on the day this picture was taken, the long-focal-length lens used by the photographer made the scene look even more crowded than it was. When do you get this effect, and why? See pages 34–35 to find out.*

Short focal length: Wide-angle lenses

Lenses of short focal length are also called wide-angle or wide-field lenses, which describes their most important feature—they view a wider angle of a scene than human vision does. A lens of normal focal length records what you see when you look at a scene with eyes fixed in one position. A wide-angle lens is like sweeping your vision from side to side, from your left shoulder to your right shoulder for the 180° viewing angle of a 7.5 fisheye lens or slightly from side to side for the 63° angle of a lens of 35mm focal length.

A short lens has great depth of field. The shorter the focal length of a lens the more of a scene will be sharp (if the f-stop and distance from the subject remain unchanged). A 28mm lens stopped down to f/8 can be sharp from less than 2m (6.5 ft) to infinity (as far as the eye or lens can see), which often will eliminate the need for focusing once the lens has been preset for maximum depth of field.

Wide-angle "distortion." A wide-angle lens can seem to distort an image and produce strange perspective effects. Sometimes these effects are actually caused by the lens, as with a fisheye lens (page 29). But more often what seems to be distortion in an image made with a wide-angle lens is because of the photographer's using the lens very close to the subject, which is easy to do with a short lens. A 28mm lens, for example, will focus as close as 0.3m (1 ft), and shorter lenses even closer. Any object seen from close up appears larger than an object of the same size that is at a distance. If you moved in very close to the vase shown below, as the photographer did (below, right), the figures on the vase would appear almost as large as the people standing behind it, just as they do in the photograph. While you are at the scene, your brain knows that you are very close to the vase and ordinarily you would not even notice the visual exaggeration. In a photograph, however, you notice the size differences immediately.

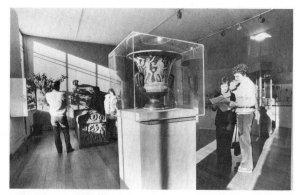

Short lenses show a wide view. *Short focal length lenses are useful for including a wide view of an area: for example, this museum room shown wall to wall. They have great depth of field so that objects both close to the lens and far from it will be in focus, even at a relatively large aperture.*

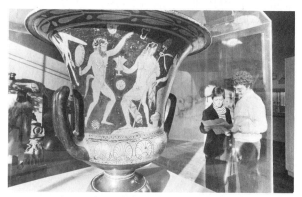

Objects up close appear larger. *A short lens can produce strange perspective effects. Since it can be focused at very close range, it can make objects in the foreground large in relation to those in the background. With the lens close to the vase, the figures on it are almost as large as the people behind it.*

Photojournalism with a short lens. *In the scene above, the photographer used a lens of 35mm focal length on her 35mm camera. This medium-short focal length gave her a wider angle of view and more depth of field than a normal (50mm) lens. This type of lens is useful in the crowded, fast-moving situations in which photojournalists often have to work. The wider angle of view lets them photograph in closer quarters than a 50mm lens does, and the increased depth of field lets them focus the lens approximately, instead of having to fine-focus every shot.*

Zoom, macro, and fisheye lenses

In addition to the usual range of short-, normal-, and long-focal-length lenses, there are other lenses that can view a scene in a new way or solve certain problems with ease.

Zoom lenses combine a range of focal lengths into one lens. (See this page, top.) The glass elements of the lens can be moved in relation to each other; thus infinitely variable focal lengths are available within the limits of the zooming range. Using a 50–135mm zoom, for example, is like having a 50mm, 85mm, and 135mm lens instantly available, plus any focal length in between. Though zoom lenses are relatively high priced and somewhat bulky and heavy, one of them will replace two or more fixed-focal-length lenses. Zoom lenses are best used where light is ample since they have a relatively small maximum aperture. New designs give considerably improved sharpness compared to earlier zoom lenses, which were significantly less sharp than fixed-focal-length lenses.

Macro lenses are used for close-up photography (this page, bottom). Their optical design corrects for the focusing faults that can occur at very short focusing distances, but they can also be used at normal distances. Their main disadvantage is relatively small maximum aperture, often about f/3.5 for a 50mm lens. (More about close-up photography in Chapter 5.)

Fisheye lenses have a very wide angle of view—up to 180°—and they exaggerate to an extreme degree differences in size between objects that are close to the camera and those that are farther away (see opposite). They actually distort the image by bending straight lines at the edges of the picture.

A zoom lens *gives you a choice of different focal lengths within the same lens. The rectangles overlaid on the picture show some of the ways you could have made this photograph by zooming in to shoot at a long focal length or zooming back to shoot at a shorter one.*

A macro lens *enabled the photographer to move in very close to this denizen of the Florida Everglades without having to use supplemental close-up attachments such as extension tubes.*

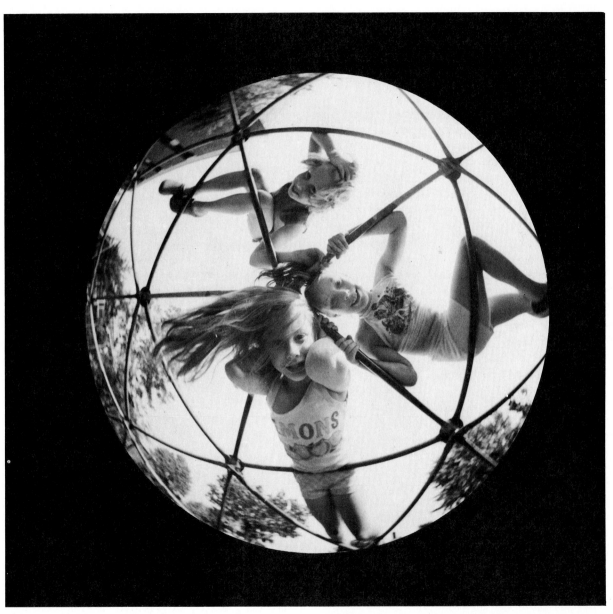

A fisheye lens *bent the straight lines of this ordinary jungle gym into a round globe shape. Objects at the edge of the fisheye's image circle are distorted more than those at the center. Notice the shape of the building at the upper left.*

Depth of field: Sharpness in a photograph

Depth of field. Dead sharp from foreground to background, totally out of focus except for a narrow strip, or sharp to any extent in between—it is possible to choose how sharp your image will be. When you focus a camera on an object, you adjust the distance between lens and film by turning the lens barrel until the object appears sharp on the viewing screen. In most cases part of the scene will be acceptably sharp both in front of and behind the most sharply focused plane. Objects will gradually become more and more out of focus the farther they are from the sharply focused area. This depth within which objects appear acceptably sharp in the image—the depth of field—can to a certain extent be made deeper or shallower.

Controlling the depth of field. When you make a picture you can manipulate three things that affect the depth of field (illustrations opposite). No-

tice that changing the depth of field may at the same time change the image in other ways.

Aperture size. Stopping down the lens to a smaller aperture, for example, from f/2 to f/16, increases the depth of field. As the aperture gets smaller, more of the scene will be sharp in the print.

Focal length. Using a shorter-focal-length lens also increases the depth of field at any given f-number. For example, more of a scene will appear to be sharp when photographed with a 50mm lens at f/8 than with a 200mm lens at f/8.

Lens-to-subject distance. Moving farther from the subject increases the depth of field most of all, and simply stepping back with your camera will make more of a sharp scene in the print. This is particularly true if you start out very close to the subject.

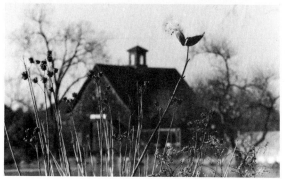

The depth of field, *the area in a scene that is acceptably sharp, extended in the top picture on this page from the weeds in the foreground to the house and trees in the background. For another picture (bottom) the photographer wanted only part of the scene to be sharp. See opposite for ways to control the depth of field in a photograph.*

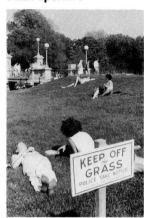

Large aperture

Small aperture

The smaller the aperture (with a given lens), the greater the depth of field. *Using a smaller aperture for the picture far right made the image much sharper. With the smaller aperture, the light reaching the film decreased, so a slower shutter speed had to be used to keep the total exposure the same.*

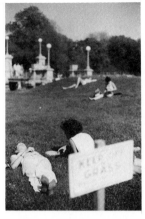

Long focal length

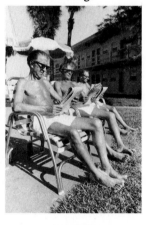

Short focal length

The shorter the focal length of the lens, the greater the depth of field. *Notice that changing to a shorter focal length for the picture far right also changed the angle of view (the amount of the scene shown) and the magnification of objects in the scene.*

Close to subject

Far from subject

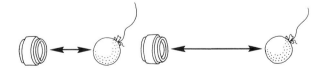

The farther you are from an object, the greater the depth of field. *The photographer stepped back to take the picture far right. If you focus on an object far enough away, the lens will form a sharp image of all objects from that point out to infinity.*

More about depth of field: How to preview it

When photographing a scene you will often want to know the extent of the depth of field—how much of the scene will be sharp. You may want to be sure that certain objects are sharp. Or you may deliberately want something out of focus, such as a distracting background. To control what is sharp, you need some way of gauging the depth of field.

Checking the depth of field. For viewing, the lens aperture is ordinarily wide open, and the viewing screen shows the scene with the depth of field at its shallowest. When the shutter release is pressed, the lens automatically stops down to the taking aperture and the depth of field increases. Most cameras have a previewing mechanism so that if you wish you can stop down the lens to view the scene at the taking aperture and tell how much of it will actually be sharp.

However, if the lens is set to a very small aperture, the stopped-down image on the screen may be too dark to be seen clearly. If so, the nearest and farthest limits of the depth of field can be read on the depth-of-field scale on the lens barrel (this page, top). Manufacturers also prepare printed tables showing the depth of field for different lenses at various focusing distances and f-stops.

Zone focusing for action. Knowing the depth of field in advance is useful when you want to preset the lens to be ready for an action shot without last-minute focusing. Zone focusing uses the depth-of-field scale on the lens to set the focus and aperture so that the action will be photographed well within the depth of field (this page, bottom).

Focusing for the greatest depth of field. When you are shooting a scene that includes important objects at a long distance as well as some that are closer, you will want maximum depth of field. Shown opposite is a way of setting the lens to permit as much as possible of the scene to be sharp.

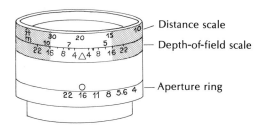

Distance scale
Depth-of-field scale
Aperture ring

With zone focusing you can be ready for an action shot by focusing in advance, if you know approximately where the action will take place. Suppose you are at a horse show and you want to photograph a horse and rider as they go over the jump. The nearest point at which you might want to take the picture is 4.5 m (15 ft) from the action; the farthest is 9 m (30 ft). Line up the distance scale so that these two distances are opposite a pair of f-stop indicators on the depth-of-field scale (with the lens shown above, the two distances fall opposite the f/16 indicators). Now, if your aperture is set to f/16 or smaller, everything from 4.5–9 m (15–30 ft) will be within the depth of field and in focus.

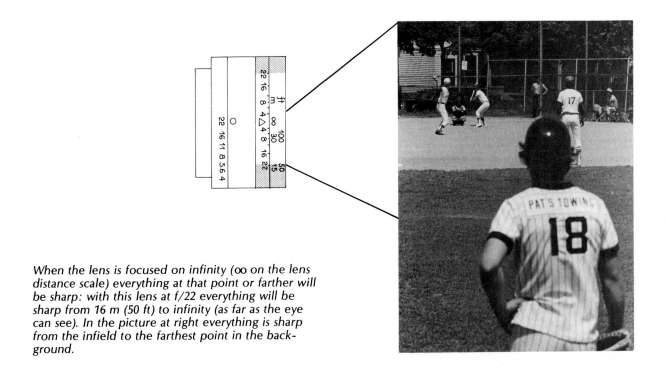

When the lens is focused on infinity (∞ on the lens distance scale) everything at that point or farther will be sharp: with this lens at f/22 everything will be sharp from 16 m (50 ft) to infinity (as far as the eye can see). In the picture at right everything is sharp from the infield to the farthest point in the background.

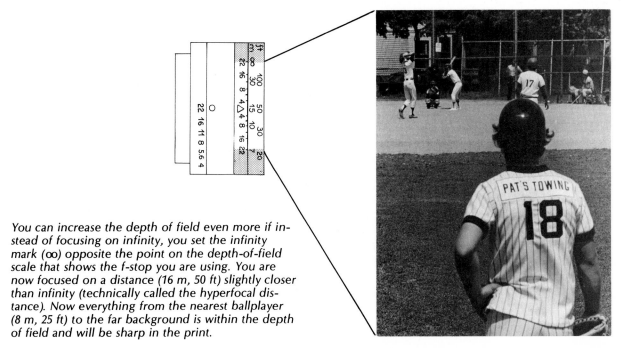

You can increase the depth of field even more if instead of focusing on infinity, you set the infinity mark (∞) opposite the point on the depth-of-field scale that shows the f-stop you are using. You are now focused on a distance (16 m, 50 ft) slightly closer than infinity (technically called the hyperfocal distance). Now everything from the nearest ballplayer (8 m, 25 ft) to the far background is within the depth of field and will be sharp in the print.

Perspective: How a photograph shows depth

Perspective: the impression of depth. Few lenses (except for the fisheye) actually distort reality. The perspective in a photograph—the apparent size and shape of objects and the impression of depth— is what you would see if you were standing at camera position. Why then do some photographs seem to have an exaggerated depth, with the subject appearing stretched and expanded (this page, left), while other photographs seem to show a compressed space, with objects crowded very close together (this page, right)? The brain judges depth in a photograph mostly by comparing objects in the foreground with those in the background, and the greater the size differences perceived, the greater the impression of depth. When viewing an actual scene, the brain has other clues to the actual distances, and it disregards any apparent distortion in sizes. But when looking at a photograph, the brain uses relative sizes as the major clue.

How perspective is controlled in a photograph. Any lens moved in very close to the foreground of a scene increases the impression of depth by in-creasing the size of foreground objects relative to objects in the background. As shown opposite, perspective is not affected by changing the focal length of the lens if the camera remains at the same distance (top row). However, it does change if the distance from lens to subject is changed (bottom row).

Perspective can be exaggerated. Perspective effects are exaggerated when changes occur in both focal length and lens-to-subject distance. A short-focal-length lens used close to the subject increases differences in size because it is much closer to foreground objects than to those in the background. This increases the impression of depth. Distances are magnified and sizes and shapes may be distorted when scenes are photographed in this way.

The opposite effect occurs with a long-focal-length lens used far from the subject. Differences in sizes are decreased because the lens is relatively far from *all* objects. This decreases the apparent depth and sometimes seems to squeeze objects into a smaller space than they could occupy in reality.

Expanded perspective. *A short-focal-length lens used close to a subject stretches distances because it magnifies objects near the lens in relation to those that are far from the lens.*

Compressed perspective. *A long-focal-length lens used far from a subject compresses space. Size differences and the impression of depth are minimized because the lens is relatively far from both foreground and background.*

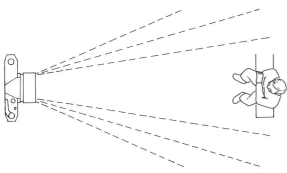

Changing focal length alone does not change perspective—*the apparent size or shape of objects or their apparent position in depth. As the focal length was increased for the photographs above, the size of all the objects increased at the same rate. Thus the impression of depth remained the same.*

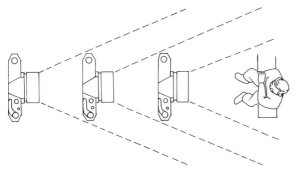

Lens-to-subject distance controls perspective. *Perspective is changed when the distance from the lens to objects in the scene is changed. Here, though the focal length remained the same, the impression of depth increased as the camera was brought closer to the subject.*

Lens performance: Getting the most from a lens

Lens motion causes blur. Though some photographers claim to be able to hand hold their cameras steady at slow shutter speeds—1/15 sec or even slower—it takes only a slight amount of lens motion during exposure to cause noticeable blur in an image. If a sharp picture is your aim, using a fast shutter speed or supporting the camera on a tripod is a much safer bet for producing an image that will be sharp when enlarged.

Preventing blur due to lens motion. The focal length of the lens being used determines how fast a shutter speed is needed to keep the image acceptably sharp during a hand-held exposure. The longer the focal length, the faster the shutter speed must be, because a long lens magnifies any motion of the lens during the exposure just as it magnifies the size of the objects photographed. As a general rule, the slowest shutter speed that is safe to hand hold can be matched to the focal length of the lens. That is, a 50mm lens should be hand held at a shutter speed of 1/50 sec or faster, a 100mm lens at 1/100 sec or faster, and so on. This doesn't mean that the camera can be freely moved during the exposure. At these speeds the camera can be hand held, but with care. The illustrations at right show ways to hold a camera in various positions. At the moment of exposure, hold your breath and squeeze the shutter release smoothly.

A tripod (right) will help you in situations that require a slower shutter speed than is feasible for hand holding, for example, at dusk when the light is dim. A tripod is useful when you want to compose a picture carefully and for close-up work. It is standard equipment for copy work because hand holding at even a fast shutter speed will not give the critical sharpness that resolves fine details to the maximum possible degree. A cable release also helps; it triggers the shutter without your having to touch the camera directly, so the camera stays absolutely still.

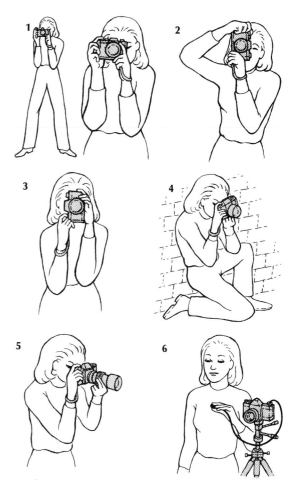

1. To hand hold a camera steadily, *keep feet apart and rest the camera lightly against your face. Hold your breath and squeeze the shutter release gently.* **2. With the camera in a vertical position,** *the left hand focuses and holds the camera with the left elbow against the chest. The right arm is raised to release the shutter.* **3. In this vertical position,** *the right hand holds the camera and releases the shutter; the left hand focuses and helps steady the camera.* **4. In kneeling position,** *kneel on one leg and rest your upper arm on the other knee. Leaning against a wall or other steady object will help brace your body whether you are kneeling or standing.* **5. With a long lens** *on the camera, use one hand to support the weight of the lens. Winding the camera strap around your wrist helps to steady the camera and to prevent dropping it.* **6. A tripod and cable release** *provide the steadiest support and are essential for long shutter speeds if a sharp image is desired.*

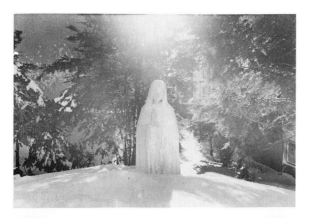

Light problems. *Flare (top) grays the image when light strikes the front of the lens, even if the source is not in the picture. Vignetting (bottom) is the result of using a lens hood that is too small and so cuts into the image area.*

Stray light can cause problems. You can't make an exposure without light, but light can also be the undoing of your picture. The sun, a bright bulb, or other light source within the image can cause ghosting, bright spots in the shape of the lens diaphragm that show in the picture. They are caused by stray light bouncing around inside the lens.

Flare, an overall graying of the image, is also caused by stray light. Though the sun itself was not in the picture at top, sunlight struck the lens at an angle. The result was an additional exposure of non-image-forming light that reduced picture contrast.

A lens hood helps. Flare is best controlled by using a lens hood or shade to shield the lens from direct light. A lens hood should be used with the focal length of lens for which it was designed or it may cut into the image and vignette the edges (bottom). Check carefully for vignetting if you are using a filter plus a lens hood or two filters together.

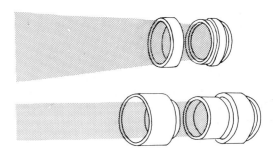

Lens hoods *clip or screw onto the front of a lens and are made in different sizes to match different focal lengths.*

3 Film and exposure

Exposing film properly *is not hard to learn. To let just the right amount of light into the camera, you need to understand just three things:*

1. How the shutter speed and the size of the lens opening (the aperture) work together to control light (pages 10–15).

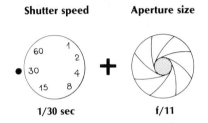

Shutter speed	Aperture size
1/30 sec	f/11

2. The sensitivity of each kind of film to light—its speed (pages 42–43).

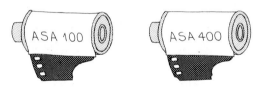

3. How to meter the light to measure its brightness (pages 50–55).

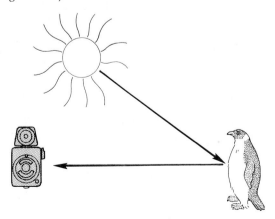

The exposure of film to light is one area in which a little expertise pays off in much better pictures. Exposing the film correctly often makes the difference between a rich image with realistic tones, dark but detailed shadows, and bright, delicate highlights instead of a too dark, murky picture or a too light picture that is barely visible.

At the simplest level, you can rely on the chart of exposure recommendations the film manufacturer provides with each roll of film. You can also let an exposure meter make decisions for you. Some meters built into cameras set the aperture and/or shutter speed for you automatically.

In many cases these standardized procedures will give you a satisfactory exposure. But standard procedures don't work in all situations. If the light source is behind the subject, for example, an average reading will silhouette the subject against the brighter background. This may not be what you want.

You will have more control over your pictures—and be happier with the results—if you know how to interpret the information the meter provides and how to adjust the recommended exposure to give any variation you may choose. You will be able to select what you want to do in a specific situation rather than exposing at random and hoping for the best.

Film characteristics: How film works

The light sensitivity of film. The most basic characteristic of film is that it is light-sensitive; it undergoes a chemical change when exposed to light. Light is energy, a visible form of the wavelike energy that extends in a continuum from radio waves through visible light to gamma rays. These forms of energy differ only in their wavelength, the distance from the crest of one wave to the crest of the next. The visible part of this spectrum, the light that we see, ranges between 400 and 700 millimicrons, or millionths of a millimeter.

All films do not respond the same way to light. Silver halides, the light-sensitive part of film, respond primarily to blue and ultraviolet wavelengths,

but dyes can be incorporated in the emulsion to increase their range of sensitivity. General-purpose black-and-white and color films are panchromatic, or pan; they are designed to be sensitive to most wavelengths of the visible spectrum so that the image they record is similar to that perceived by the human eye. Some special-purpose films are designed to be sensitive to other parts of the spectrum. Orthochromatic, or ortho, black-and-white films are sensitive primarily to blue and green wavelengths. Infrared films are sensitive to infrared wavelengths that are invisible to the eye. See page 46. Since some films are designed to perform certain jobs better than others, it is useful to be aware of their different characteristics.

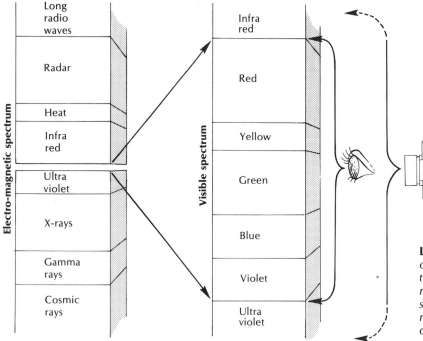

Light. *When certain wavelengths of energy strike the human eye, they are perceived as light. Film is manufactured so that it too is sensitive to this part of the electromagnetic energy spectrum. In addition, film is sensitive and responds to certain wavelengths that the eye cannot see, such as ultraviolet and infrared light.*

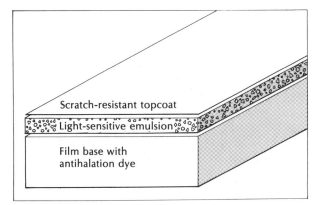

Scratch-resistant topcoat
Light-sensitive emulsion
Film base with
antihalation dye

Film cross section. *Film is made up of layers of different materials. On top is a tough coating that helps protect the film from scratches during ordinary handling. Next is a layer of gelatin emulsion that contains the light-sensitive part of the film, silver halide crystals. (Color film has several layers of halides, each sensitive to a different part of the spectrum.) An adhesive bonds the emulsion to the base, a flexible support of either cellulose acetate or polyester. To prevent light rays from bouncing back through the film to add unwanted exposure to the emulsion, an antihalation dye that absorbs light is added to the film base.*

Film terms

Color sensitivity The parts of the visible spectrum to which a film responds. See opposite.

Film speed The overall sensitivity of a film to light as compared to other films. See next page.

Latitude The amount that film can be overexposed or underexposed and still produce an acceptable print or slide.

Grain The granularity or speckled effect produced by tiny specks of silver in the emulsion clumping together. See next page.

Contrast The range of tones from dark to light that a film produces. Films of normal contrast show blacks, whites, and a wide range of tones in between. High-contrast black-and-white films record all the tones in a scene as either black or white or something close to these extremes. Low-contrast films record a scene in tones of mostly middling darkness with less apparent difference in the image between the lightest and darkest areas.

Emulsion The light-sensitive coating applied to photographic films and papers. It consists of silver halide crystals of silver chloride, silver bromide, and silver iodide, plus other chemicals, suspended in gelatin. The ability of silver halides to darken on exposure to light makes photography possible.

Base The backing of film or paper on which emulsion is coated.

Negative An image, usually on film, with tones that are the opposite of those in the original scene; light areas in the original are dark in the negative, dark areas are light.

Positive An image on paper or film with tones that are the same as those in the original scene.

Transparency Usually, a positive color image on film. A slide is a transparency mounted in a small frame of cardboard or other material so it can be inserted in a projector or viewer.

Reversal processing The procedure by which a positive image is made directly from a scene or from another positive; making a color slide directly from film exposed in the camera is an example.

Film speed and grain: The two go together

Film speed ratings. How sensitive a film is to light, that is, how much it darkens when exposed to a given quantity of light, is indicated by its film speed number (in the U.S. this is an ASA rating; in Europe, a DIN rating). The more sensitive—or faster—the film, the higher its number in the rating system.

A high film speed is often useful: the faster the film, the less exposure it needs to produce an image, and so fast films are often used for photographing in dim light. But along with fast film speed go some other characteristics: an increase in grain and decrease in contrast and often in sharpness. As the illustrations on this page show, the most detailed image was produced by the slow, ASA 32 film. The very high speed ASA 1250 film by comparison gave a more mottled, grainy effect and recorded a less detailed image.

Graininess occurs when the bits of silver that form the image clump together, and it is more likely to happen in fast films, which have large silver halide crystals, than it is with slower films having smaller crystals. The effect is more noticeable in big enlargements or if the film is not processed at carefully maintained temperatures, if it is overexposed, or if it is "pushed" to increase its film speed by special development.

What film speed should you use? Theoretically, for maximum sharpness you should choose the slowest film usable in a given situation. For practical purposes, however, many photographers use a medium-fast film in most situations and switch to a slow film only when extremely fine detail is of special importance.

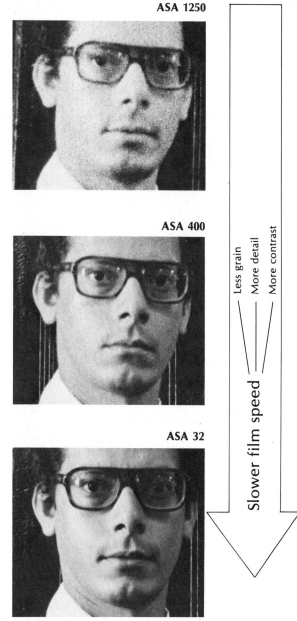

ASA 1250

ASA 400

ASA 32

Less grain
More detail
More contrast

Slower film speed

Film speed and grain. *Generally speaking, the slower the film speed (the lower the ASA or DIN film speed rating), the finer the grain structure of the film and the more detailed the image the film records. Compare the extreme enlargements above. Film speed also affects the color qualities of color materials like slide films.*

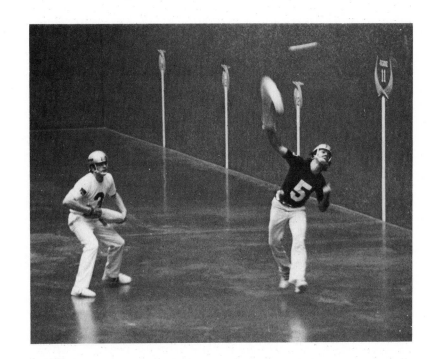

A fast film, *ASA 400, made it possible to shoot these jai alai players in action under the available light on their indoor court. The shutter speed was short enough (1/60 sec) so that the players are reasonably sharp, but the ball was moving so fast it appears as a streak above one of the men.*

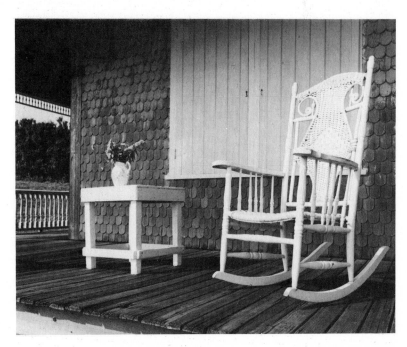

A slow film, *ASA 32, recorded fine detail in the wicker chair as well as grain and texture in the siding and floor of the porch. The image would be crisp and detailed even if enlarged to a much bigger size than shown here.*

Buying and using film

Buying film. Whatever kind of film you buy, check the expiration date printed on the film package before you make your purchase. The film will still be usable beyond that date but it will steadily deteriorate after that.

Storing film. Heat accelerates the deterioration of film, so avoid storing it in warm places like the inside of a glove compartment on a hot day or the top of a radiator on a cold one. Room temperature is fine for short-term storage, but for longer storage a refrigerator or freezer is better. Be sure that the film to be chilled is in a moisture-proof wrapping, and when you remove the film from refrigeration, avoid condensation of moisture on the film surface by letting it come to room temperature before opening it.

Loading. Light exposes film, and you want only the light that comes through the lens to strike the film. So, load and unload your camera away from strong light to avoid the possibility of stray light leaking into film cassettes and causing streaks of unwanted exposure. Outdoors, at least block direct sun by shading the camera with your body when loading it.

A medium-speed film, *ASA 125, was chosen for this photograph of vines trailing over a low wall. The fine grain and excellent sharpness of the film recorded every tendril and even the delicate white lines on the leaves. This picture was made in relatively dim light, so the photographer used a tripod to support the camera during the long exposure.*

A fast film, *such as one rated at ASA 400, is good not only for action shots but for any situation in which the light is relatively dim and you want to work with a fast shutter speed or a small aperture.*

Special-purpose films: High contrast and infrared

Most films are designed to "see" as the human eye does and to respond to light in ways that appear realistic. But some films depart from the reality that we know.

High-contrast black-and-white film does not record a continuous range of tones from black through many shades of gray to white; instead it translates each tone in a scene into either black or white (see illustration opposite). Some 35mm materials are specially made for high-contrast photography. Some continuous-tone films (like Panatomic X) can also be specially processed for high contrast.

Infrared black-and-white film is sensitized to wavelengths that are invisible to the human eye, the infrared waves that lie between visible red light and wavelengths that produce heat. Since the film responds to light that is not visible to the eye, it can be used to photograph in the dark. Unusual and strangely beautiful images are possible because many materials reflect and absorb infrared radiation differently from visible light (see below). Grass, leaves, and other vegetation reflect infrared wavelength very strongly and thus appear very bright, even white. Clouds too are highly reflective of infrared wavelengths, but since the blue sky does not reflect them it appears dark, even black, in a print. Because the wavelengths are invisible, you cannot fully visualize in advance just what the print will look like—sometimes a frustration, but sometimes an unexpected pleasure. The correct exposure is also something of a guess; most meters do not measure infrared light accurately.

The sun is a strong source of infrared radiation, and tungsten filament lamps, flash bulbs, and electronic flash can also be used. Ordinarily a red filter is used on the lens to eliminate all but the infrared wavelengths. Most lenses focus infrared wavelengths slightly differently from visible light. So after visually focusing as usual, rack the lens forward very slightly as if focusing on a nearer object. Some lenses have a red indexing mark on the lens barrel to show the adjustment needed. Infrared color film is also available.

Infrared film *records leaves and grass as very light, the blue sky as very dark. The result can be a strangely dreamlike landscape.*

High contrast film *changes the many shades of gray in an ordinary scene into a graphic abstraction of blacks and whites.*

When film is exposed to light: Normal, under-, and overexposure

A negative is the first image that results when film is exposed to light. A negative is the reverse of the original scene: the brightest areas in the scene are the darkest in the negative. How does this happen? When light strikes film the energy of the light activates light-sensitive silver halide crystals in the film emulsion. The energy rearranges the structure of the crystals so that during development they convert to particles of dark metallic silver.

The more light that strikes a particular area, the more that the light-sensitive crystals are activated, and the darker that part of the negative will be. As a result, a white house, for example, will be very dark in the negative. If film is exposed to light long enough, it darkens simply by the action of light, but ordinarily it is exposed only long enough to produce a latent or invisible image that is then made visible by chemical development.

To get from the negative to a positive print the negative is printed, usually by shining light through it, onto a piece of light-sensitive paper. Where the original scene was bright (the clouds), the negative is very dark and dense with many particles of silver. Dense areas in the negative block light from the positive; few particles of silver form there, and the areas are bright in the final image.

The opposite happens with dark areas like the shutters in the original scene: dark areas reflect little light, so only a little (or even no) silver is produced in the negative. When the positive is made, these thin or clear areas in the negative pass much light to the positive and form dark deposits of silver corresponding to the dark areas in the original scene. When a positive transparency like a color slide is made, the negative is chemically processed into a positive.

Underexposed negative

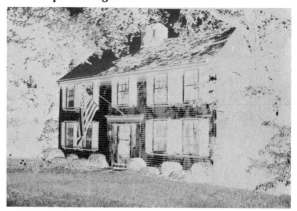

Normal negative

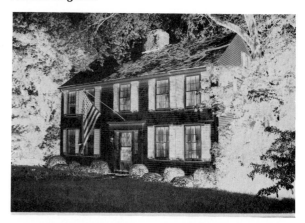

Overexposed negative

Dark positive

Normal positive

Light positive

Exposure determines the darkness of the image.
The exposure you give a negative (the combination of f-stop and shutter speed) determines how much light reaches the film and how dark the negative will be: the more light, the darker the negative, and, in general, the lighter the final image. The correct exposure for a given situation depends on how you want the photograph to look.

Film and paper have exposure latitude, that is, a good print can often be made from a less-than-perfect negative. Color slides have the least latitude: for best results they should not be overexposed or underexposed more than ½ stop (1 stop is acceptable for some scenes). See page 61 for more about exposing color film. Black-and-white or color prints can be made from negatives that vary somewhat more: about 1 stop underexposure to 3 stops overexposure is usually acceptable.

But with too much variation from the correct exposure, prints and slides begin to look bad. Too much light overexposes the negative; it will be much too dense with silver to pass enough light to the final print, which in turn will be too pale (illustrations, bottom). Conversely, too little exposure produces a negative that is too thin, resulting in a print that is much too dark (illustrations, top).

Bracketing helps if you're not sure about the exposure. First give the combination of f-stop and shutter speed that you think is the right one. Then make a second shot with more exposure (by opening to the next larger aperture or shooting at the next slower shutter speed). Then, make a third shot with less exposure (the next smaller aperture from your original exposure or the next faster shutter speed). Usually one of the three will be about right. Look at your negatives or slides after processing to see the effects caused by the different exposures. Your camera may have an exposure override, a control that increases or decreases the exposure by a given amount.

Exposure meters: What different types do

Exposure meters vary in design but all perform the same basic function. They measure the brightness of light, then for a given film speed they calculate f-stop and shutter speed combinations that will produce a properly exposed negative.

Hand-held meters. The light-sensitive part of a meter is a photoelectric cell. When the cell of a hand-held meter (one that is not built into a camera) is exposed to light it rotates a calculator dial, or moves a needle across a scale of numbers, or activates a digital display. The greater the amount of light, the higher the reading. The meter then calculates and displays a series of recommended f-stop and shutter speed combinations. See illustration below.

Built-in meters. A meter that is built into a camera operates on the same principle, but it may do some or all of the calculation and adjustment for you. Exposing the photoelectric cell to light measures the brightness of the light. In some models the user sets either the aperture or the shutter speed and the camera automatically adjusts the other to give the correct exposure. In other models the user adjusts the aperture and shutter speed until a needle is centered or matched in the viewfinder. Instead of a needle, some models have a light-emitting diode display that flashes to indicate the correct exposure.

Meter batteries. Some hand-held meters and all meters built into cameras are powered by small batteries. It is important to check the batteries regularly (see manufacturer's instructions for how to do this). An exhausted battery will cause the meter to give the wrong reading or to cease to function altogether.

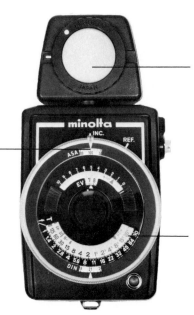

Exposing the light-sensitive cell of this meter to light...

The ASA (or other film speed rating) of the film being used is set into the meter.

...rotates a moving scale of numbers (the calculator dial). When the dial stops moving, recommended f-stop and shutter speed combinations are shown that will properly expose the film.

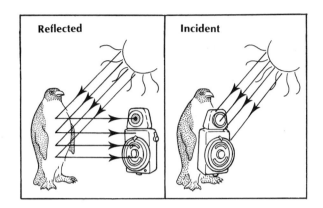

A reflected-light meter *measures the amount of light reflected from an object. To make a reading, point the meter at the entire scene or at a specific part of it. Most hand-held meters and all of those built into cameras are reflected-light meters.*

An incident-light meter *measures the amount of light falling on an object. The meter's light-sensitive cell is pointed at the camera to measure the amount of light falling on the subject as seen from camera position.*

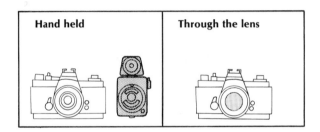

Hand-held meters *are separate from the camera and are convenient for metering various parts of a scene from up close.*

Through-the-lens (TTL) meters *are built into many SLR cameras. The viewfinder shows the area that the meter is reading. TTL meters may be coupled to the camera to set the exposure automatically or they may simply indicate the correct exposure.*

Cameras with automatic exposure.

Shutter-priority exposure: *the photographer sets the shutter speed, and the camera mechanism changes the aperture until the correct exposure is set.*

Aperture-priority exposure: *the photographer chooses the aperture, and the camera mechanism adjusts the shutter speed.*

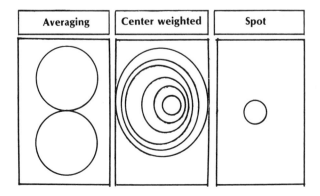

How much of a scene does a meter measure? *An averaging or overall meter reads most of the image area and computes an exposure that is the average of all the brightnesses in the scene. Center-weighted meters overlap their readings to concentrate on the central area of an image, which is usually the important one to meter. A spot meter reads only a small part of the image. Very accurate exposures can be calculated with a spot meter, but it is important to select with care the area to be read. More about which areas to read appears on the following pages.*

Making an overall reading of an average scene

"It came out too dark." Sometimes beginning photographers complain that they made a meter reading but the picture still wasn't properly exposed. All an exposure meter does is measure light. It can't think or reason, so it doesn't know what part of the scene you are pointing it at, whether a particular object is supposed to be light or dark, or how you want the final print or slide to look.

You have to think for the meter and sometimes change the exposure that it recommends. Even built-in meters that automatically set aperture or shutter speed have an override mechanism that lets you change the exposure. Don't be afraid to do this; only *you* know the picture you want.

A reflected-light meter averages the light entering its angle of view, which, except for spot meters, is about the same angle as that of a normal-focal-length lens, 30° to 50°. The meter is calibrated on the assumption that in an average scene all the tones—dark, medium, and light—will add up to an average medium gray. So it recommends an exposure that will record the total of light it is reading as medium gray on the negative.

This works well if you are photographing a subject with an average distribution of light and dark areas, for example, most general landscapes or street scenes, especially if the light either is coming from behind you or is evenly diffused over the scene. How to make an overall reading of this type of average or low contrast scene is shown opposite.

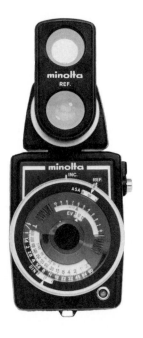

A reflected-light meter (either hand held or built into a camera) averages all the tones in its angle of view, then recommends an average exposure. You can use the meter's recommended exposure if you are photographing an "average" scene such as the one here. But you may want to adjust this exposure if the subject does not have an average range of tones, for example, if it is a backlit scene with high contrast (more about this on the next pages).

Calculating an exposure with a hand-held, reflected-light meter.

1. Set the film speed into the meter.

2. Point the meter's photoelectric cell at the subject at the same angle seen by the camera. Activate the meter to measure the brightness of the light reflected by the subject. (If a bright sky is part of the picture, as here, point the meter down slightly to read mostly the landscape.) The meter shown here has an optional 10° spot attachment with an optical finder that lets you see the area being metered.

3. Choose one of the combinations of f-stops and shutter speeds shown on the calculator dial and set the camera accordingly. Any combination shown on the dial lets the same quantity of light into the camera and produces the same exposure.

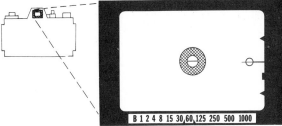

Meters built into the camera *vary in design and operation, but on all you will be able to see in the viewfinder window a needle or other indicator that shows when the camera is set for a correct average exposure.*

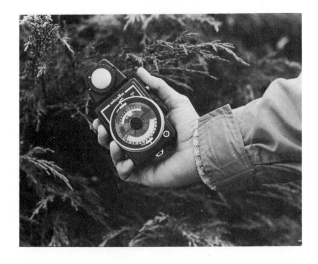

Calculating an exposure with an incident-light meter.

1. Set the film speed into the meter.

2. Point the meter's photoelectric cell away from the subject—toward the camera lens. Activate the meter to measure the brightness of the light falling on the subject. (Make sure the same light is actually falling on the meter as on the subject. For example, do not accidentally shade the meter if the subject is brightly lit.)

Proceed as in step 3 above.

Metering scenes with high contrast

Metering is easy for a scene of average or low contrast (pages 52–53). But you need to take a little extra care with a scene of high contrast, one in which the meter shows several stops difference between light areas and dark areas. Since the meter averages all the brightnesses it sees, the reading may be shifted up or down too much to expose the main subject properly if your subject is surrounded by a much darker area such as a large, deep shadow or a much lighter one such as a bright sky. This is particularly true with color slides because they quickly show the result of too much or too little exposure.

To meter a contrasty scene you will need to measure the light level for the most important part of the picture. There are several ways to do this. First try to meter just the main subject. If you are photographing a person or some other subject against a much darker or lighter background, move in close enough so that you exclude the background from the reading—though not so close that you meter your own shadow. If your main subject is a landscape or other scene that includes a very bright sky, tilt the meter down slightly so you exclude most of the sky from the reading.

A substitution reading is possible if you can't move in close enough to the important part of a contrasty scene. Look for an object of about the same tone in a similar light that you can read instead. For very exact exposures professional photographers may meter the light reflected from a gray card, a card of standard middle gray of 18 percent reflectance (meters are designed to calculate exposures for ideal subjects of 18 percent reflectance). You can also meter the light reflected by the palm of your hand (see opposite, bottom).

An underexposed, too dark photograph *can happen when the light is coming from behind the subject or when the subject is against a very bright area such as the sky. The problem is that a reflected light meter averages all the brightnesses that strike its light-sensitive cell and here the photographer pointed the meter at the much brighter sky as well as at the person.*

A better exposure for contrasty scenes *results from moving up close to meter only the main subject, as shown opposite top and center. This way you take your meter reading from the most important part of the scene.*

Move in close to meter a high-contrast scene, one where the important part of the picture is either much lighter or much darker than other parts of the image. With a hand-held, reflected-light meter (top), move in close enough to read the subject but not so close as to block the light. With a built-in meter (center), move in (without blocking the light) until the important area just fills the viewfinder or until you are sure you are reading the main subject. Set the shutter speed and aperture and move back to the original position to take the picture.

With a zoom lens, you can often zoom in to read just the main subject, then return the zoom to the focal length you want to use. A spot meter, which reads light from a very narrow angle of view, is particularly useful for metering high-contrast scenes.

A substitution reading, such as one taken from the palm of your hand, will give you an accurate reading if you can't get close enough to a subject. Try the exposure recommended by the meter if you have very dark skin, but give one stop more exposure if you have light skin, as here.

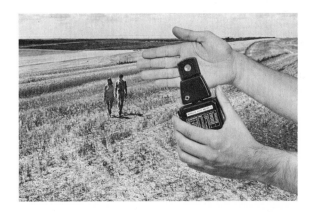

Exposures in hard-to-meter situations

What do you do when you want to make a photograph but can't make a meter reading—photographing fireworks, for instance, or a city skyline at night? Guessing and making a couple of experimental tries is better than nothing, and you might get an image you'll like very much. If you keep a record of the scene and your exposures, you will at least have an idea how to expose a similar scene.

Bracketing is a good idea: make at least three shots —one at the suggested exposure, a second with 1 or 1½ stops more exposure, and a third with 1 or 1½ stops less exposure. Not only will you probably make one exposure that is acceptable, but each of the exposures may be best for a different part of the scene. For instance, at night on downtown city streets a longer exposure may show people best while a shorter exposure will be good for brightly lit shop windows.

Very long exposures may turn out too dark even if you think the exposure was calculated correctly. The problem here is that a very long exposure at a very low light level does not affect the film as strongly as you would expect it to (technically the reciprocity effect). For exposures of 1 second or longer, increase the total exposure by ½ to 1 stop; for exposures of 10 seconds or longer, increase 1 to 2 stops; for exposures of 100 seconds or longer, increase 2 to 3 stops. See instructions packed with film for more detailed information.

In hard-to-meter situations, *Kodak suggests the exposures at right for films rated at ASA 400 (the equivalent of DIN 27). Give twice as much exposure (1 stop more) for films rated at ASA 125 to ASA 200 (DIN 22 to DIN 24).*

*For color pictures of scenes marked with * use a tungsten-balanced film for the most natural color. You can also use daylight-balanced color film, but your pictures will look yellow-red. For color pictures of scenes marked with † use daylight film. You can also use tungsten film with an 85B (amber) filter over your camera lens; if you do this give 1 stop more exposure than that indicated in the table. (More about film color balance on pages 62–63.)*

*Home interiors at night—Areas with average light	1/30 sec f/2
*Candlelighted close-ups	1/15 sec f/2
Indoor and outdoor holiday lighting at night, Christmas trees	1/15 sec f/2
Brightly lighted downtown streets	1/60 sec f/2.8
Brightly lighted nightclub or theatre districts, e.g., Las Vegas	1/60 sec f/4
Neon signs and other lighted signs	1/125 sec f/4
Store windows	1/60 sec f/4
Subjects lighted by streetlights	1/15 sec f/2
Floodlighted buildings, fountains	1/15 sec f/2
Skyline—distant view of lighted buildings at night	1 sec f/2.8
Skyline—10 minutes after sunset	1/60 sec f/5.6
Fairs, amusement parks	1/30 sec f/2.8
Amusement park rides—light patterns	1 sec f/16
Fireworks—displays on ground	1/60 sec f/4
Fireworks—aerial displays (Keep shutter open for several bursts.)	f/16
Lightning (Keep shutter open for one or two streaks.)	f/11
Burning buildings, campfires, bonfires	1/60 sec f/4
Subjects by campfires, bonfires	1/30 sec f/2
*Night football, baseball, racetracks	1/125 sec f/2.8
Niagara Falls—White lights	4 sec f/5.6
Light-colored lights	8 sec f/5.6
Dark-colored lights	15 sec f/5.6
Moonlighted—Landscapes	8 sec f/2
Snow scenes	4 sec f/2
*Basketball, hockey, bowling	1/125 sec f/2
*Boxing, wrestling	1/250 sec f/2
*Stage shows—Average	1/60 sec f/2.8
*Circuses—Floodlighted acts	1/60 sec f/2.8
*Ice shows—Floodlighted acts	1/125 sec f/2.8
†Interiors with bright fluorescent light	1/60 sec f/4
*School—stage and auditorium	1/30 sec f/2
*Hospital nurseries	1/60 sec f/2.8
*Church interiors—tungsten light	1/30 sec f/2

What exposure would you use with ASA 400 film for this shot at dusk of the river boat "Belle of Louisville"? If the chart at left doesn't have exactly the situation you are photographing, look for a related one. As a start for an exposure for this scene you might try the one recommended for "Skyline—10 minutes after sunset." Then bracket additional exposures.

4 Color

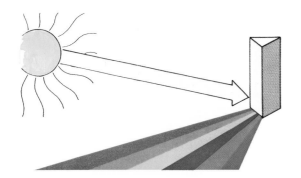

"White" light, *such as that from the sun, contains all the colors of the spectrum. Pass light through a prism and it will break into a rainbow of colors.*

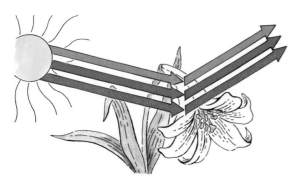

A lily appears white *because it reflects all the wavelengths of light that strike it. When these reach the eye, the color white is perceived.*

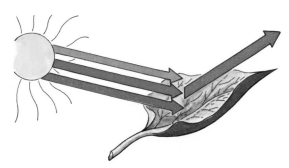

A leaf appears green *because when light strikes it, the leaf absorbs all but the wavelengths that create the visual sensation of green.*

Why a separate chapter on color? The basic camera-handling techniques are the same as for black and white, and you can load up a roll of color film, shoot, and probably get pretty good pictures. But you will get more consistent results and be happier with what you get if you know a little about how color film reacts to light. This chapter tells what to expect from color film and how to use it to make better pictures.

Color slides and prints are appealing because color makes the picture seem more realistic than the same scene rendered in black and white. Black-and-white film records the shape of things and their tones from light to dark, but the black-and-white image is still very much an abstraction. An image in color is more like the real one. It is more apt to remind you of exactly how the scene looked when you took the picture and to make viewers who weren't there feel that they are really seeing the scene too.

Color pictures can also be deliberately *unrealistic*. A purple sky, a green horse, color streaks, and other manipulations are possible with color materials and may be just what you want on occasion.

Where does color come from? Light from the sun appears to have no tint or color of its own; it is "white" light. But it actually contains all colors, and if you project it through a prism it will separate into a band of colors like a rainbow. A colored object—a leaf, for example—has color because when light strikes it, the leaf reflects the greenish components or wavelengths of the light while absorbing other colors. The eye is sensitive to these reflected wavelengths and sees them as green. Dyes, as in paint or color prints, act just as the leaf does in selectively absorbing and reflecting certain wavelengths of light and so producing color.

59

Color film characteristics

What can you get in color films? There are many brands and types of color film on the market. They belong basically to two main categories: negative films and reversal films (see below). A negative film (such as Kodacolor or Agfacolor) produces a negative in which the tones and colors are the opposite of those in the original scene. The negative is then printed onto paper or film to make a positive image. A reversal film (such as Kodachrome or Fujichrome) is given special reversal processing to produce a positive transparency or slide.

Color films come in a range of film speeds, from slow ASA 25 to fast ASA 400. Just as with black-and-white films, more film speed brings some increase in grain and decrease in sharpness. Film speed also affects the color rendition of the film, with faster films generally less intensely colored (less saturated) than are slower films. Different films are also made to be used with specific light sources such as sunlight or tungsten light (see pages 62–63).

Color reversal films vary from brand to brand, and slides of identical film speed but from different manufacturers will show variations in color balance, color saturation, grain, and other characteristics. Personal taste is important here, and it is useful to expose the same scene on different types of film and compare the processed slides to choose the film you prefer. Color negative films also vary from brand to brand, but less noticeably than do reversal films.

Color film *consists of three light-sensitive layers, each of which responds to about one-third of the colors in the light spectrum. Each layer is matched to a primary color dye that is built into the emulsion or added during processing, and every color in the spectrum can be produced by mixing varying proportions of these color primaries.*

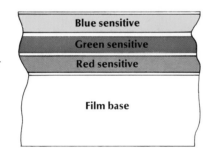

Blue sensitive
Green sensitive
Red sensitive

Film base

Negative color film *is first processed for a negative image and then the negative is printed to make a positive image. Reversal color film produces the familiar transparency or slide that is viewed by projection; it is a positive color image on the film exposed in the camera. A slide can also be printed on paper, to make another positive image.*

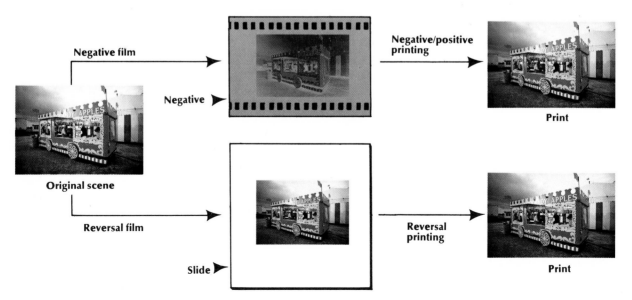

Negative film

Negative

Negative/positive printing

Print

Original scene

Reversal film

Slide

Reversal printing

Print

Scenes in soft, flat light *are the easiest to expose correctly because the lightest areas in the scene are not much brighter than the darkest ones, so there will be no overly bright or too dark areas in the final photograph.*

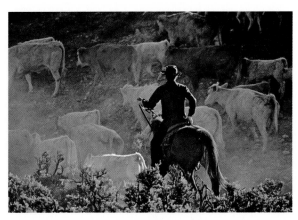

Backlit scenes *and other scenes in bright, direct light often have some important areas very light or others very dark or both. You have to choose which area is the most important to you and meter that part of the scene for your exposure.*

Correct exposure is essential for slides. If you want slides with clear, brilliant colors and good detail in important parts of the picture, you must expose the film correctly. Too much exposure produces slides that are too light and have pale, washed-out colors. Too little exposure produces dark, murky slides with little texture or detail. Sometimes you may want to deliberately underexpose or overexpose an image to get these effects, but in most cases, the best results come from exposures that are no more than ½ stop over or under the optimum.

How do you determine the "correct" exposure? When metering, move in close enough to read the most important part of the picture: someone's face, for example. Calculating the exposure on the brightness of this area will produce the best colors for it—and for all other areas in the scene that register the same brightness on the meter. The colors of much brighter or much darker areas will not be as good, but this is not usually a problem if these areas are less important.

Some scenes are more difficult to expose than others. The easiest scenes to expose correctly are those that are evenly lit with the meter showing little difference in brightness between the darkest and lightest areas (this page, top). Scenes like this can vary as much as one stop from the optimum exposure and still produce good results.

If a scene is contrasty, however—if it has dark shadows plus brilliantly lit areas as well (this page, center)—no single exposure will be correct for everything in the scene. If the shadowed areas are exposed correctly, the bright areas will be too light; exposing for the bright areas will make the shadowed ones too dark. Try exposing for the most important area, then bracketing additional exposures. Pages 88–89 tell how to brighten shadow areas by adding fill light. Pages 68–69 tell how to use dark shadows for dramatic effect.

Color balance: Matching film with light source

The color temperature of light—the mixture of wavelengths of different colors that it contains—varies with different light sources. Daylight, for example, is much bluer than light from an ordinary light bulb. Consequently, different types of color films are balanced to match the color temperatures of specific light sources.

Color films are balanced either for daylight or tungsten light. Daylight-balanced films yield the most natural looking colors when shot in daylight or other light that is rich in blue wavelengths. Tungsten-balanced or indoor films look best when used in more reddish light, such as from tungsten bulbs. (See illustrations opposite.) Most indoor films are called tungsten-balanced and are designed to be used with light of 3200°K color temperature; however, they give acceptable results when used with any type of tungsten light. Type A indoor film has a slightly different balance for use with high-intensity 3400°K photolamps.

Color balance is important with reversal films. Color slides are made from the film that was in the camera, which must be shot either in the light for which it was intended or with a filter over the lens to adjust the color balance. If this is not done, the resulting slides will have a distinct color cast.

Color temperature is less critical with some films. Color negative films are somewhat tolerant of different color balances because these can be adjusted during printing. Some color negative films, such as Kodacolor 400, minimize color balance differences between light sources even more. Black-and-white film can be shot in light of any color temperature.

The color temperature of a light source (measured in degrees Kelvin) is a way of describing its color exactly. Color films are made to be used either with daylight, relatively blue in color, or with tungsten light, which is more reddish. The lower the color temperature, the more "warm" red wavelengths there are in the light. Higher color temperatures have more "cool" blue wavelengths.

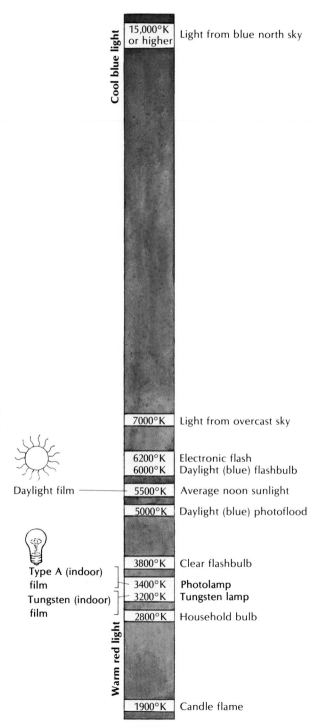

Cool blue light

15,000°K or higher — Light from blue north sky

7000°K — Light from overcast sky

Daylight film — 6200°K — Electronic flash
6000°K — Daylight (blue) flashbulb
5500°K — Average noon sunlight
5000°K — Daylight (blue) photoflood

3800°K — Clear flashbulb

Type A (indoor) film — 3400°K — **Photolamp**
Tungsten (indoor) film — 3200°K — **Tungsten lamp**
2800°K — Household bulb

Warm red light

1900°K — Candle flame

Tungsten film in daylight

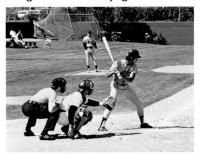

Daylight film in daylight

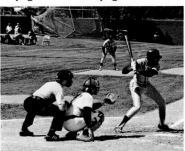

Daylight-balanced films are designed for a light source that is rich in blue wavelengths and low in red, such as daylight (especially near noon), electronic flash, and blue flash bulbs (see illustration near left). If you shot the same scene on tungsten-balanced film, the resulting pictures, particularly slides, would look quite blue (see far left). Tungsten films can be used in daylight if an 85 (amber) filter is placed over the lens and the exposure increased by about 1 stop.

Daylight film in tungsten light

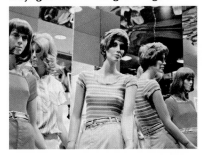

Tungsten film in tungsten light

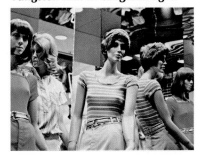

Tungsten-balanced films are designed for a light source that is the opposite of daylight: rich in red wavelengths, low in blue—as from household bulbs, photofloods, and clear flash bulbs (see near left). If you shot the same scene on daylight-balanced film, the resulting color balance would be reddish-orange (see far left). Daylight film can be corrected for tungsten if an 80 (blue) filter is placed over the lens and the exposure increased by about 2 stops. However, light indoors is often too dim for such an increase.

Fluorescent light

Fluorescent light plus FL filter

Fluorescent light presents a special problem because the color balance does not match either daylight or tungsten films, and it also depends on the type of fluorescent tube and its age. The light often gives an unpleasant greenish cast to pictures (far left). Film manufacturers provide filtration data for different tubes, but practically speaking the photographer usually doesn't know which tube is installed. Try an FL (fluorescent) filter with 1 stop increase in exposure (near left). Daylight film will give a better balance than tungsten film if you use no filter.

Changes in color balance: Time of day/Weather

Have you ever had a picture come out an unexpected color (even when you used the correct film)? Perhaps a snowy scene in the shade turned out too blue, or a beach scene at sunset looked too orange. If you have, you may know how easy it is to fool the eye when it comes to color balance. Film that is manufactured to render colors accurately in the relatively blue light (high color temperature) at noon, will show colors differently if the color temperature shifts even slightly, for example as it gets lower and more reddish at sunset.

Color temperature outdoors varies at different times of day and so produces different color balances on film. You'll find these shifts easier to notice if you are looking for them. Before dawn, colors are greyed and monochromatic. As the sun comes up, colors begin to stand out more clearly, but they appear more reddish than they will later in the day because in the early morning the color temperature of the sun's rays is modified as the rays travel a relatively long distance through the earth's atmosphere.

Daylight-type film is balanced for the color temperature of sunlight between about 10 A.M. and 2 P.M. During these hours, when the sun is most directly overhead, its rays are modified least by the atmosphere. Colors appear bright, clear, and accurate.

At sunset, the rays are again changed by the atmosphere. Blue rays are filtered out, leaving a surplus of reddish rays that turn color pictures taken at this time a warm, reddish-orange color. This reddish cast may be acceptable with some subjects; wood or skin usually appear natural in tone even when the color temperature has shifted considerably to reddish-orange. But other subjects do not work as well; in a snowy winter scene photographed

On a foggy day, colors are greyed and softened, particularly in the background. The color balance of pictures will be different under different atmospheric and light conditions.

at sunset, the snow may turn an unnaturally pink color that merely appears odd. At dusk, colors are muted again and gradually become greyed and monochromatic as they were before dawn.

Atmospheric conditions also affect color balance. In the fog, snow, or rain, or on a heavily overcast day, colors are often muted. On these days, the farther that objects are from the camera the more their colors are toned down. Sometimes a colored object in the foreground appears particularly bright because it is seen against a greyed background.

On a sunny day at noon, *a picture taken at the same beach shown on the opposite page will have clear, bright colors that snap out sharply.*

At sunset, *colors take on a reddish cast as the color temperature of the light lowers. Skin tones may appear quite orange but still pleasing.*

Unexpected colors: Blue shadows/Very long exposures

The eye and brain quickly adapt to changes in color balance, especially if they have nothing to compare the color to directly; they tend to see a color as they expect it to be rather than as it is. If you know a dress to be white, your eye and brain see it as white even though it may have a distinctly green cast because of color reflected from grass or trees nearby. Color film is very sensitive to shifts in color balance and can produce unexpected results in the final picture if you are not watching for color casts when you shoot.

Shadow areas often appear bluer in color photographs than we expect them to be. On a sunny day, we tend to see shadows as simply dark, but they are receiving illumination from the indirect and very blue light of the sky. Color portraits taken in the shade (which provides a soft, pleasing modeling of facial features) are often improved in color balance if a UV (ultraviolet) or 1A (skylight) filter is used to eliminate some of the excess blue that is not always complimentary to skin tones.

Very long exposures (1 second or longer) cause shifts in color balance that can't be seen or even anticipated very well. During long exposures, film responds more slowly than usual (the reciprocity effect) and you may find your pictures underexposed as a result. In addition, the fact that each of the three layers of film emulsion responds at a different rate causes color balance to shift as well (see opposite).

To prevent underexposure with times of 1 sec or longer, increase the exposure as explained on page 56. Color shifts can add interest to sunsets and other pictures, but if you wish to minimize them during long exposures, see the manufacturer's information sheet packed with the film for filters you can use.

Blue shadows outdoors are one of the unexpected colors often found in color photographs. The shadows on the snow are obviously blue in the photograph above, but were not so easy to see when the picture was taken. See also photograph below left.

A portrait outdoors in the shade can have a slightly blue cast (left). A UV (ultraviolet) or a 1A (skylight) filter will remove some of the blue; an 81A (yellow) filter will remove even more (right).

Unexpected colors *can come from exposures of 1 sec or longer. The longer the exposure, the more you are likely to get shifts in the color balance of the picture. A magenta sky (left) is one of the commonest effects of a long exposure at sunset. Above, a long exposure in the evening produced an intensely yellow picture of a London bridge.*

Using dark shadows

Deep, dark shadows can be a problem, particularly in color slides, because, as explained on page 61, a color slide has only about ½ stop leeway in exposure. If you underexpose an important area in a color slide by more than ½ stop it will become significantly darker; it may be totally black if underexposed by several stops. But you can use this effect deliberately if you wish, in slides and in other photographs, silhouetting an interesting shape against a lighter background or accenting a brightly lit area that is of interest to you by surrounding it with a mass of dark shadows.

A silhouette *against a cafe window was made by metering the brightness of the window to calculate the exposure.*

A portrait half in shade *can be made by metering and exposing for the lit side of the face when the shaded side of the face is much darker.*

Silhouetting a subject against the sky can happen unintentionally if you include a bright sky in your meter reading. In the picture above of Natural Bridges National Monument the photographer deliberately metered the sky for the exposure. The rock formation was several stops darker than the sky and thus was so much underexposed it appeared as almost black. At right, dark hills and bushes frame a picture of sheep grazing in the Sierra Nevada Mountains.

5 Special techniques

Many special techniques and manipulations are possible with photography. This chapter concentrates on two major areas: close-ups and the use of lens attachments and filters.

Close-ups. We are used to seeing and photographing things from viewing distances of several feet or more. But many subjects—a tiny insect, the swirling petals of a flower—have a beauty and intricacy that are seen best from up close. Filling the entire picture with a detail of an object can reveal it in a new and unusual way.

The single-lens reflex is an excellent camera for close-up work because you view the scene through the lens and see the exact image that the lens records (cameras without through-the-lens viewing show a different viewfinder angle than the one the lens projects on the film). Depth of field is usu-ally very shallow when you photograph up close, and an SLR lets you preview which parts of the close-up will be sharp. If your camera has a built-in meter, its through-the-lens metering helps you calculate exposures accurately when using close-up accessories like extension tubes or bellows that decrease the amount of light reaching the film. Pages 78–81 tell more about close-ups and how to make them.

Lens attachments and filters. A single-lens reflex is also a good choice if you want to use lens accessories like cross-screen or multiple-image attachments. As you view the scene you can adjust the attachment right on the lens until you get just the effect you want. The next pages show some of these lens attachments and tell how to use filters that change colors and contrast.

Moonlight effect. *Tungsten-balanced film will produce an image that is too blue for most pictures if it is shot in daylight without a filter to convert the light balance from a daylight color temperature to a tungsten color temperature (as shown on page 63). But if you shoot without a filter and also underexpose the film, you get an effect that looks very much like a moonlit scene (see right). Daylight film with an 80B blue filter produces a similar effect.*

Using filters: How to change film's response to light

Filters for color photography. Filters are often used in color photography to match the color balance of the light to that of the film so that the resulting picture looks more realistic. Using an FL (fluorescent) filter, for example, decreases the greenish cast of pictures taken under fluorescent light (shown on page 63). Or you can use filters to make a color photograph depart from reality, as, for example, in the seascape at right. Various filters for color photography are listed in the chart opposite.

Filters for black-and-white photography. Most black-and-white films are panchromatic—sensitive to all colors to about the extent that the human eye is. However, blue colors tend to record somewhat lighter in black-and-white photographs than we expect them to, and one of the commonest uses for filters is to darken a blue sky so that clouds stand out more distinctly (shown this page). The chart opposite lists some of the filters used in black-and-white pictures.

Color generates an emotional response *and an unexpected color can make an image strikingly unusual. A deep yellow filter was used for this seascape.*

A blue sky may appear very light in a black-and-white photograph *because film is sensitive to the blue and ultraviolet light present in the sky.*

A deep yellow filter was used *on the camera lens for the black-and-white photograph above to darken the blue sky and make the clouds stand out. A light yellow filter would have darkened the sky slightly less, a red filter slightly more.*

Filters for color film

	Type of filter	Increase needed in exposure
To get a natural color balance with daylight-balanced film exposed in tungsten light.	80A (blue) with photolamps	2 1/3 stops
	80B (blue) with ordinary tungsten bulbs	2 stops
To get a natural color balance with tungsten-balanced film exposed in daylight.	85A (amber) with Type A film	2/3 stop
	85B (amber) with Type B film	2/3 stop
To get a natural color balance with fluorescent light.	FL-B with tungsten-balanced film	1 stop
	FL-D with daylight-balanced film	1 stop
To reduce the bluishness of light on overcast days or in the shade. To penetrate haze. Used by some photographers to protect lens.	1A (skylight)	no increase
	UV (ultraviolet)	no increase
To decrease bluishness more.	81A (yellow)	1/3 stop
To decrease the red-orange cast of light at sunset and sunrise.	82A (blue)	1/3 stop
To balance film precisely as recommended by film manufacturer.	CC (color compensating): R (red), G (green), B (blue), Y (yellow), M (magenta) C (cyan)	varies
To experiment with color changes.	any color	varies according to effect desired

See next pages for lens attachments for special effects.

Filters for black-and-white film

		Type of filter	Increase needed in exposure
To darken blue objects in order to: Make clouds stand out against blue sky.	natural effect	8 (yellow)	1 stop
	darker	15 (deep yellow)	1 1/3 stops
Reduce haze in distant landscapes.	very dark	25 (red)	3 stops
Make blue water darker in marine scenes (effect shows if sky is blue).	darkest	29 (deep red)	4 stops
To increase haze for atmospheric effects in landscapes. To lighten blues to show detail, as in flowers.		47 (blue)	2 2/3 stops
To lighten reds to show detail, as in flowers.		25 (red)	3 stops
To lighten greens to show detail, as in foliage.		58 (green)	2 2/3 stops
To make the range of tones on panchromatic black-and-white film appear more like the range of brightnesses seen by the eye.		8 (yellow) with daylight	1 stop
		11 (yellow-green) with tungsten light	2 stops

Filters for color or black-and-white film

	Type of filter	Increase needed in exposure
To decrease amount of light reaching film so slower shutter speed or wider aperture can be used.	neutral density	varies with density of filter

Increasing exposures when filters are used. Filters work by removing some of the wavelengths of light that pass through them. To compensate for the resulting overall loss of light intensity, the exposure must be increased or the film will be underexposed. Cameras with through-the-lens meters can measure the light through a filter on the lens and, in most cases, will adjust the exposure as needed. Some types of meter cells may be more sensitive to certain colors than others, so check your owner's manual for special instructions. If you do not have a through-the-lens meter, increase the exposure manually as suggested by the filter manufacturer or as listed in the charts above.

Lens attachments: Polarization, stars, and other effects

A polarizing screen can remove reflections. If you have ever tried to photograph into a store window and seen more of the reflections from the street than whatever you wanted to photograph on display inside the store, you know how distracting unwanted reflections can be. Using a polarizing screen is a way to eliminate some of these reflections. The screen eliminates or decreases reflections from glass, water, or any smooth nonmetallic surface.

Landscapes can be sharper and clearer with a polarizing screen. Light reflected from minute particles of water vapor or dust in the atmosphere can make a distant landscape look hazy and obscured. A polarizing screen will decrease these minute reflections and allow you to see more distant details. It may also help to make colors purer and more vivid by decreasing unwanted coloring such as reflections of blue light from the sky.

The screen works best at certain angles to your subject (see diagrams this page). The screen attaches like a filter to the front of the camera lens. With an SLR you can look through the viewfinder and adjust the screen until you get the effect you want. An exposure increase of 1 to 2 stops is usually required.

Distracting reflections *in the top photograph almost obscure the display inside the shop window. A polarizing screen on the camera lens removed most of the reflections in the bottom photograph so that the objects inside can be seen clearly.*

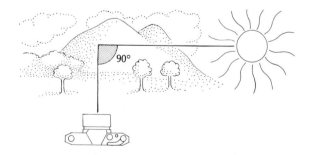

When shooting landscapes, *using a polarizing screen makes distant objects clearer. The effect is strongest at a 90° angle to the sun.*

A polarizing screen removes reflections *from surfaces such as glass. The screen works best at a 30°–40° angle to the reflecting surface.*

Special effects with lens attachments. A star of light from a skyscraper window? Multiple images of a clump of wildflowers recorded several times on the negative or slide with just one exposure? In addition to the filters that change tone or color, other lens attachments manipulate or change the image itself. They can add drama to an otherwise ordinary picture, blur details to make an image soft and romantic, or change a scene in other unusual ways. If you take one or two along in your camera bag you might find uses for them that you hadn't expected. See the selection of lens attachments illustrated on the next pages.

A cross-screen lens attachment, *sometimes called a star filter, put the bright star of light in the photograph below. A four-ray attachment created the rays around the reflection of the sun in a window. Other cross screens produce six, eight, or more rays.*

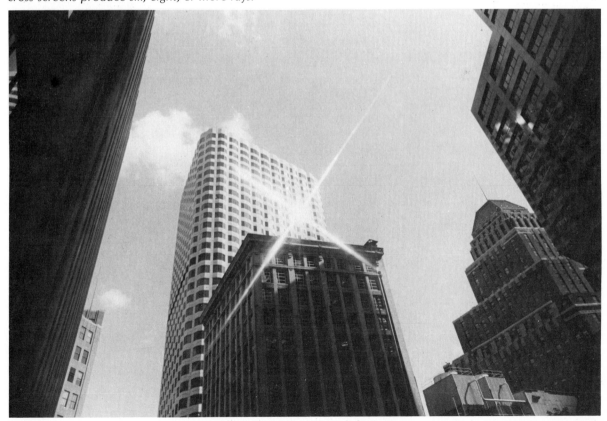

Lens attachments for special effects

	Without attachment	With attachment	Effect
			Soft focus Softens details and can make bright highlights shimmer and gleam.
			Spot lens A sharp central field becoming progressively hazy at the edges. For emphasizing details of a subject.
			Prism 3X (triangular) Triangular prism without a central image.
			Prism 3X (parallel) Multiple prism with three parallel fields. Reproduces the subject side by side, tilted, or one above the other.
			Prism 5X A central field and four marginal sectors give a five-image reproduction.
			Prism 6X Image is reproduced six times with five images arranged around a central field.
			Color prism 3X (parallel) Three parallel fields with colors changing gradually from yellow to green, blue, and purple.
			Color prism 6X Pentagonal arrangement of five fields around the center field, with same color changes as above.

	Without attachment	With attachment	Effect
			Prism 6X (parallel) The subject is repeated six times with one large image and five adjacent, parallel ones.
			Close-up prism Makes a close-up of a small object while at the same time doubling it—side by side, one above the other, or at parallel angles.
			Split field or bifo Part of the filter surface is a close-up lens and the rest is clear glass. Thus objects at close range (approx. 24 cm or 10 in.) and those far away can be focused sharply at the same time.
			Eccentric spot lens An off-center split field allows both a distant object and a very close one to be focused sharply.
			Cross screen (four-ray, six-ray, eight-ray) Each point source—a point of bright light or bright reflection—radiates rays of light.
			Spectra (4X, 8X) Each point source of light radiates starlike beams in three spectral colors. Especially visible in night scenes.
			Spectra (2X) Parallel beams of spectral colors emanate from every point light source.
			Spectra (48X) Petal-shaped spectral beams around each point light source.
			Spectra (72X) Color spectra emanate from each point light source.

Courtesy of B+W Filterfabrik

Close-ups: Bigger and better

Close-up equipment. Shown opposite are the different types of close-up equipment you can use to produce a larger-than-normal image on your negatives. All of them do the same thing: they let you move in very close to the subject you are photographing.

Whether to use a camera support like a tripod depends on what and where you are photographing. You will be more mobile without one—ready to photograph an insect that has just alighted on a branch or to get down very close to a low-growing wildflower. However, close-up exposures are often longer than normal, and a tripod helps prevent camera motion with a slow shutter speed. Also, a tripod lets you compose your pictures precisely, perhaps keeping the scene framed just as you want it while you meter it or arrange the lighting.

Increased exposures for close-ups. Placing extension tubes or bellows between the lens and the camera body lets you move in close to a subject, but the farther the lens gets from the camera, the dimmer the light that reaches the film. Beyond a certain extension the exposure must be increased or the film will be underexposed. A camera that meters through the lens increases the exposure automatically if compatible extension tubes or bellows are used. But if your camera does not meter through the lens, you must increase the exposure manually. To do so, follow the recommendations given by the manufacturer of the tubes or bellows, or see the chart, below. Close-up lenses (see opposite) do not require an exposure increase.

Life size (1:1) on film, enlarged to 2X life size here

1/10 life size (1:10) on film, enlarged to 1/5 life size here

Close-up terms. *The closer your camera is to a subject, the larger the image on the film. A close-up is any picture taken closer-than-normal to the subject—specifically, when the image on the film ranges from about 1/10 life size (1:10) to as big as life size (1:1). Macrophotography generally refers to an image on film that is life size (1:1) to as big as ten times life size (10:1). Photomicrography, photographing through a microscope, is usually used to get a film image larger than 10:1.*

Exposure increase needed for close-ups (Increase applies to a lens of any focal length used with a 35mm camera.)

If the long side of the area being photographed measures in inches	11	5 1/8	3 1/4	2 1/4	2	1 3/4	1 3/8	1
in cm	28	13	8.5	5.75	5	4.5	3.5	2.5
Open lens aperture this many f-stops	1/3	2/3	1	1 1/3	1 1/2	1 2/3	2	2 1/2
Or multiply exposure time by	1.3	1.6	2	2.5	2.8	3.2	4	5.7

A close-up lens attaches to the front of a camera lens and lets you focus up close without using extension tubes or bellows. Close-up lenses come in different strengths (diopters); the stronger the diopter, the closer you can focus and the larger the image. Close-up lenses are relatively inexpensive, small, and easy to carry along in your camera bag, and they do not require additional exposure as do extension tubes or bellows.

Extension tubes and bellows fit between the lens and the camera. They increase the distance from the lens to the film; the greater this distance, the closer you can bring the lens to the subject. Extension tubes come in graduated sizes that can be used in various combinations to make different size close-ups. A bellows is more adaptable than are fixed-length tubes because it can be expanded to any length. Using either tubes or bellows means increasing the exposure, as explained opposite.

Reversing a lens produces a sharper image when the lens is used very close to the subject. At a short focusing distance an ordinary lens is being used under conditions for which it was not designed, and as a result image sharpness decreases; reversing the lens improves this. Even a macro lens produces a sharper image if it is reversed when used so close that the image is larger than life size (1:1). An adapter ring couples the lens to the camera in reversed position.

A macro lens is your best choice for sharp close-ups. It produces a very sharp image at close focusing distances, whereas an ordinary lens produces its sharpest image at normal distances. A macro lens's mount can be extended more than that of an ordinary lens, which means that even without the use of extension tubes or bellows it can produce an image up to about half life size (1:2).

More about close-ups

Depth of field is shallow in close-ups. At close focusing distances, as little as an inch or two or even less of the depth in the scene will be sharp, and the closer the lens comes to the subject, the more the background and foreground go out of focus. Accurate focusing is essential or it may miss the subject altogether. Small apertures help by increasing the depth of field but they also increase the length of the exposure time. It may be necessary to use a tripod and, if you are photographing outdoors, to shield your subject from the wind to prevent its moving during the exposure.

Making the subject stand out from the background. Since a close-up is usually one small object or part of an object, rather than an entire scene, it is important to have some way of making the object you are photographing stand out clearly from its background. If you move your camera around to view the subject from several different angles you may find that from some positions the subject will blend into the background, while in others it becomes much more dominant. You can choose your shooting standpoint accordingly.

Shallow depth of field can be an asset in composing your picture. You can use it to make a sharp subject stand out distinctly from an out-of-focus background. Tonal contrast of light against dark, the contrast of one color against another, or the contrast of a coarse or dull surface against a smooth or shiny one can also make your close-up subject more distinct.

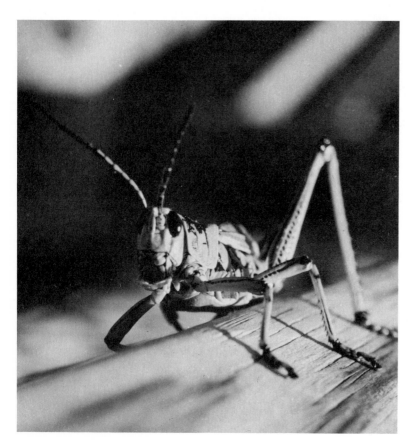

Depth of field is very shallow when a photograph is made close to a subject. *Only the insect's head and upper body are in focus; the front and rear legs and even the tips of the antennae are not sharp. The shallow depth of field can be useful: since the sharply focused parts contrast with the out-of-focus areas, the insect stands out clearly from the foreground and background.*

Cross lighting brought out the details in the intricate folds of this slice of cabbage. The main light angled across the subject from one side, while a weaker fill light close to the camera lightened the shadows.

Lighting close-ups outdoors. Direct sunlight shining on a subject will be bright, and you can use smaller apertures for greater depth of field. But direct sunlight is contrasty, with bright highlights and very dark shadowed areas. Fill light helps to lighten the shadows if this is the case (pages 88–89). Light that comes from the back or side of the subject often enhances the subject by showing texture or by shining through translucent objects so they glow. In the shade or on an overcast day, the light is gentle and soft, good for revealing shapes and details.

Flash can be added to increase the light level if you need to use a smaller aperture or shorter shutter speed, and you can also use flash as a fill light. Using the flash very close to the subject may make the light too bright; draping a handkerchief over the flash (out of the way of the camera lens) will soften the light and decrease its intensity.

Lighting close-ups indoors. You have more control over the lighting if you are arranging it yourself indoors, but stop for a moment and think out just what you want the lights to do. For flat subjects the lighting is not critical just so long as it is even. Two lights of equal intensity, each at the same distance and angle from the subject, will illuminate it uniformly.

If you want to bring out texture, one light angling across the subject from the side will pick out every ridge, fold, and crease. With a deeply textured object, you may want to add a second light close to the lens to add fill light so that important details are not lost in shadows.

6 Lighting

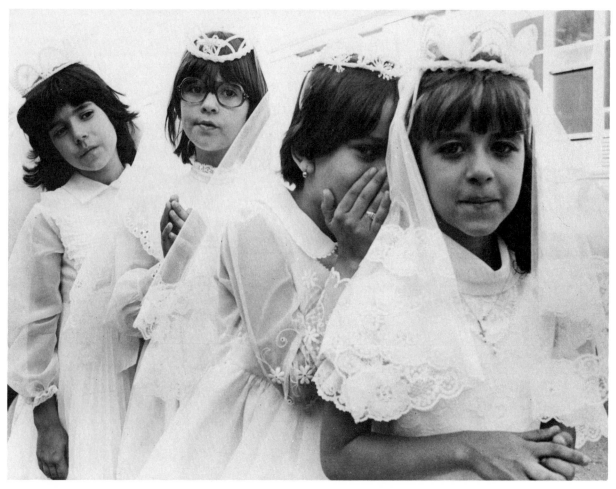

Changes in lighting will change your picture. Outdoors, if clouds darken the sky or you change position so that your subject is lit from behind or you move from a bright area to the shade, your pictures will change as a result. Light changes indoors, too: perhaps your subject moves closer to a sunny window or you turn the overhead lights on or you decide to use flash lighting.

Changes in lighting affect the exposure of your film and the color balance of the light (important with color films). Just as important, the light can affect the feeling of the photograph so that the subject appears, for example, brilliant and crisp, hazy and soft, stark, romantic, or any of many other ways. If you make a point of looking at the light on your subject, you will soon learn to predict how it will look in your photographs; and you will find it easier to use existing light or arrange the lighting yourself to give just the effect you want.

Look at the light on your subject. Soft, diffuse light bathes a communion scene, opposite. A father and daughter on a crabbing expedition (above) are darkly silhouetted against reflections from water. Light can be as important a part of the picture as the subject itself.

Qualities of light: From direct to diffused

Whether indoors or out, light can range from direct and contrasty through many intermediate steps to diffuse and soft. Here's how to predict where you will find these different qualities of light and how they will look in your photograph.

Direct light is high in contrast. It creates bright highlights and dark shadows with sharp edges. Photographic materials, particularly color slides, cannot record details in very light and very dark areas at the same time; so in a slide the colors in directly lit areas will appear brilliant and bold while shadowed colors may turn out almost black. If you are photographing in direct light, you may want to add fill light (pages 88–89) to lighten shadows. Because the intensity of direct light probably will be high, you can use a small aperture to give plenty of depth of field, a fast shutter speed to stop motion, or both, if the light is bright enough. The bright sun on a clear day is a common source of direct light. Indoors, a flash or photolamp pointed directly at your subject (that is, not bounced off another surface) also provides direct light.

Directional/diffused light is intermediate in contrast. It is partly direct and partly diffused. Shadows are present, but they are softer and not as dark as in direct light. Colors are bright and more likely to be accurately rendered in both highlights and shadows. You will encounter this type of light on a cloudy day when the sun's rays are somewhat scattered so that light comes from the surrounding sky as well as from the sun. A shaded area, such as under trees or along the shady side of a building, can have directional/diffused light if the light is bouncing onto the scene primarily from one direction. Indoors, a skylight or other large window can give this type of light if the sun is not shining directly on the subject. Light from a flash or photolamp can also be directional/diffused if it is softened by a translucent diffusing material placed in front of the light or if it is bounced off another surface like a wall or an umbrella reflector.

Direct light

Light changes—from place to place and at different times of day. Compare the qualities of the light in these portraits. Direct light (above)—hard edged and contrasty. Directional/diffused light (opposite, top)—softer-edged shadows. Diffused light (opposite, bottom)—indirect and soft.

Diffused light is low in contrast. It bathes subjects in light from all sides so that shadows are weak or even absent. Colors are less intense than they are in direct light and are likely to be pastel or muted in tone. Since the intensity of the light will be less than with direct light, you might not be able to use a small aperture with a fast shutter speed. The sun on a heavily overcast day casts diffused light because the light is coming from the whole dome of the sky rather than just from the small disc of the sun. Indoors, diffused light can be created with a very large source of light used close to the subject (such as light bounced into a large umbrella reflector) plus additional fill light.

84

Directional/diffused light

Diffused light

The main light: The strongest source of light

The most realistic and usually the most pleasing lighting resembles daylight, the light we see most often: one main source of light from above creating a single set of shadows. Lighting seems unrealistic (though there will be times when you will want that) if it comes from below or if it comes from two or more equally strong sources that produce shadows going in different directions.

Shadows create the lighting. Although photographers talk about the quality of "light" coming from a particular source, it is actually the shadows created by the light that can make an image harsh or soft, menacing or appealing. To a great extent the shadows determine the solidity or volume that shapes appear to have, the degree to which texture is shown, and sometimes the mood or emotion of the picture.

The main light, the brightest light shining on a subject, creates the strongest shadows. If you are trying to set up a lighting arrangement, look at the way the shadows shape or model the subject as you move the main light around or as you change the position of the subject in relation to a fixed main light.

Direct light from a 500-watt photolamp in a reflector was used for these photographs, producing shadows that are hard edged and dark. Direct sunlight or direct flash can produce the same effects. The light would be softer if bounced onto the subject from another surface, like an umbrella reflector, or if it was diffused. Fill light (see next pages) will lighten the shadows.

Front lighting. *Here the main light is placed close to the lens, as when a flash unit attached to the camera is pointed directly at the subject. Fewer shadows are visible from camera position with this type of lighting than with others, and, as a result, forms seem flattened and textures less pronounced. Many news photos and snapshots are front lit because it is simple and quick to shoot with the flash on the camera.*

High 45° lighting. *If the main light is moved high and to the side of the camera, not precisely at 45° but somewhere in that vicinity, shadows model the face to a rounded shape and emphasize textures more than with front lighting. This is often the main light position used in commercial portrait studios; fill light would then be added to lighten the shadows.*

Side lighting. *A main light that is at about a 90°
angle to the camera will light the subject brightly on
one side and cast long shadows across the other side.
When the sun is low on the horizon at sunset or sun-
rise, it can create side lighting that adds interest to
landscapes and other outdoor scenes. Side lighting is
sometimes used by portrait studios to dramatize a
subject.*

Top lighting. *With the light directly overhead, long
dark shadows are cast into eye sockets and under
nose and chin, producing an effect that is seldom
appealing for portraits. Unfortunately, top lighting is
not uncommon—outdoors at noon when the sun is
overhead or indoors when the main light is coming
from ceiling fixtures. Fill light to open up the shad-
ows will help.*

Back lighting. *Here the light is moved around farther
to the back of the subject than it is in the photograph
above. If the light were directly behind the subject
the entire face would be in shadow with the hair
outlined by a rim of light. Outdoors, bright light that
comes from behind the subject can silhouette it un-
less fill light from the front is used to lighten the
shadows.*

Bottom lighting. *Lighting that comes from below
looks distinctly odd in a portrait. This is because light
on people outdoors or indoors almost never comes
from below. This type of light casts unnatural shad-
ows that often create a menacing effect. Some pro-
ducts, however, like glassware, are effectively lit from
below.*

The fill light: To lighten shadows

A sunny day is an inviting time to go photographing. But, particularly for portraits, bright, direct sunlight may create harsh, contrasty shadows that come out too dark in the final photograph. This can be corrected by adding fill light to lighten the shadows. Fill light is useful indoors where light also can be contrasty.

Fill light outdoors. It is easier to obtain a pleasant expression in a sunlit outdoor portrait if your subject is lit from the side or from behind and is not squinting directly into the sun. However, this position may make the shadowed side of the face too dark. To decrease the contrast between the lit and shadowed sides of the face, fill light from a reflector or flash unit can be added, as illustrated below.

Fill light is also used outdoors for closeups of flowers or other objects in which the shadows would otherwise be too dark.

When do you need fill light? Photographic materials, particularly color slides, can successfully record color and texture in either brightly lit areas or in deeply shadowed ones, but not in both at the same time. So if important shadow areas meter more than one or two stops darker than highlight areas, consider whether adding fill light will improve your picture, especially if you are shooting color slides. The fill light should not overpower the main light but simply raise the light level of shadow areas.

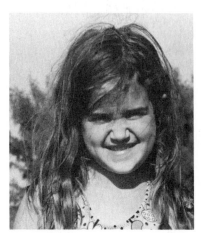

Front light. *The girl's face is illuminated brightly by sunlight shining directly on it. But facing into the sun almost guaranteed an awkward squint against the bright light.*

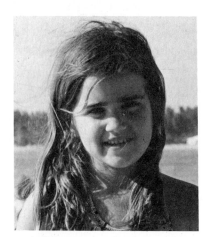

Back light. *Here she faces away from the sun and has a more relaxed expression. However, most of her face is now in shadow; it is dark in this print and would be even darker in a color slide. Increasing the exposure would lighten the shadowed side of her face but would make both the lit side of her face and the bright background very light.*

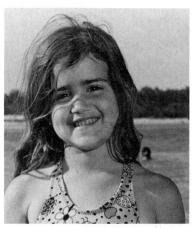

Back light plus fill light. *Here she still faces away from the sun, but to lighten the shadows the photographer has added fill light from a small flash unit on the camera.*

Using a reflector for fill light. *A large light-colored cloth or card can lighten shadows in back-lit or side-lit portraits by reflecting back some of the illumination from the main light. For color photographs, the reflector should be neutral in color so that an unwanted color is not cast on the subject. Sometimes nearby objects will act as natural reflectors, for example, sand, snow, water, or a light-colored wall.*

At right, an assistant holds the reflector for the photographer, but in many cases the reflector could simply be propped up. The closer the reflector is to the subject, the more light it will reflect into the shadows. For a portrait, meter the lit side of the face to determine the basic exposure. Then try to angle the reflector to add enough fill light so the shadowed side of the face is about one stop darker than the sunlit side.

Using flash for fill light. *To lighten the shadows on the woman's face, the photographer at right has attached a flash unit to his camera. If the flash light is too bright it can overpower the main light and create an unnatural effect. To prevent this, the photographer has draped a handkerchief over the flash head to decrease the intensity of the light. He could also have stepped back from the subject or, with some units, decreased the light output of the flash.*

See your owner's manual for instructions on how to set your camera and flash for fill lighting. In general, you will need to decrease the brightness of the flash on the subject until it is about one stop less than the basic exposure from the sun. Position the fill light close to the camera (attached to the camera is fine) so as not to cast a second set of shadows that will be visible from camera position.

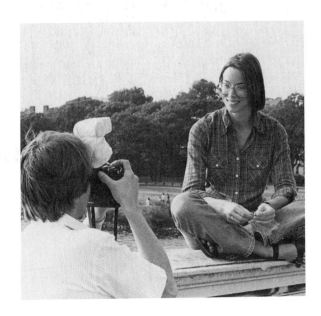

Using artificial light: Photolamp or flash

Artificial light sources let you bring your own light with you when the sun goes down or you move inside into a darkened room or you need just a little more light than is available naturally. Artificial sources are consistent and never go behind a cloud just when you're ready to take a picture. You can manipulate them to produce any effect you want —from light that looks like natural sunlight to underlighting that is seldom found in nature. Different sources produce light of different color balances, an important factor if you are using color films. See pages 62–63 for more about color balance and films.

Continuously burning lamps such as photolamps and quartz lamps plug into an AC electrical outlet. Since they let you see how the light affects the subject, they are excellent for portraits, still lifes, and other stationary subjects that give you time to adjust the light exactly. Determining the exposure is easy: you meter the brightness of the light just as you do outdoors. The color balance of these lights is matched to tungsten-balanced color films: the lamps emit either a 3400°K color temperature for use with Type A color film or 3200°K for Type B film.

Flashbulbs are conveniently portable, powered by small battery units. Each bulb puts out one powerful, brief flash and then must be replaced. Press photographers not so many years ago could be followed by the trail of spent flashbulbs they left as they discarded a bulb after each shot. Flashbulbs are still in use for some special purposes and are also used with snapshot cameras that accept flashcube or flipflash units. Flashbulbs are blue coated for use with daylight-balanced color film or are clear for tungsten-balanced film. Bulbs that put out infrared light are also available.

Electronic flash or strobe is now the most popular source of portable light. Though initially more expensive than flashbulbs, it offers many repeated flashes without the need of replacing the bulb, so it is ultimately more economical. Power can come either from battery packs or an AC outlet. The color balance of electronic flash is best with daylight-balanced color film. Flash (either from an electronic flash or a flashbulb) is fast enough to freeze most motion; flash is therefore a good choice for lighting candid or unposed shots.

Flash must be synchronized with the camera's shutter so that the flash of light occurs when the shutter curtains are fully open. Only shutter speeds of 1/60 sec or slower synchronize with electronic flash (up to 1/125 sec with certain shutters). At faster shutter speeds the shutter curtains open only partway at any time and only part of the film would be exposed. See your owner's manual for details on how to set your camera.

Photolamp

Flashbulb and reflector

Flashcube

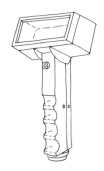
Electronic flash units

Flash exposures. Automatic flash units measure the amount of light reflected back from the subject during the flash, then terminate the flash when the exposure is adequate. Even if you have an automatic unit, there are times when you will want to calculate the flash exposure yourself, such as when the subject is very close to the flash or is very far from it and so is not within the automatic flash range.

Determining exposure with flash is different from the procedure used with other light sources. The flash of light is too short to measure with an ordinary light meter. Instead, the intensity of the light is measured by the distance of the flash from the subject, and the aperture is set accordingly. Changing the shutter speed (within the acceptable range) does not affect the exposure.

Set the aperture for a flash exposure according to how far your subject is from the flash: divide the distance from flash to subject into the guide number (a rating for the flash when used with a specific film speed); the result is the f-stop that should be used. Flash units have a calculator dial that will do the division for you: dial in the ASA of the film and the distance from the subject, and the dial will show the correct f-stop. Notice that the farther the subject is from the flash, the dimmer the light that it receives and so the larger the aperture opening that is needed to maintain the same exposure.

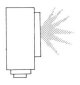

 5 ft

 10 ft

 20 ft

Guide number is 80 with this flash unit used with ASA 100 film. Distances in these examples are measured in feet.

$$\frac{\text{Guide number}}{\text{Distance from flash to subject}} = \text{f-stop}$$

$$\frac{80}{5} = 16$$

$$\frac{80}{10} = 8$$

$$\frac{80}{20} = 4$$

f/16

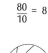

f/8

f/4

More about flash

Flash is easy to use for portrait lighting: the flash of light exposure is so fast that you don't have to worry about the subject moving during the exposure—particularly important with children—and you can expose at the instant your subject has the expression you want. Light from flash is so quick (1/1000 sec or shorter) that you can't really see what the subject looks like when lit. However, with a little practice you can predict the qualities of light that are typical of different flash positions. Shown opposite are some simple lighting setups for portraiture.

A few cautions with flash. If you have the flash close to the lens and the sitter is looking directly at the camera, you may find that your subject's eyes appear red or amber in a color picture. This is because light is reflecting from the blood-rich retina inside the eye. The effect can be easily prevented by having the subject look slightly to one side or by holding the flash away from the camera. If your subject wears eyeglasses, this will also prevent bright reflections from them. Reflections from shiny backgrounds like mirrors and windows can be avoided with flash by shooting at an angle to them, as illustrated below.

Unwanted reflections. *When using flash you may fail to notice bright, distracting reflections caused by light bouncing back from reflective surfaces like shiny walls, mirror, or glass.*

To avoid reflections *with flash, shoot at an angle to highly reflective surfaces. The light will be reflected off at an angle instead of returning to the camera.*

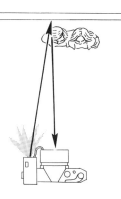

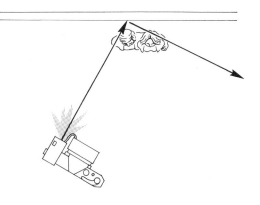

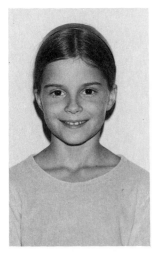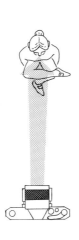

Direct flash on camera *is simple and easy to use because the flash is attached to the camera. However, the light shining straight at the subject from camera position tends to flatten out volumes and has a rather harsh look.*

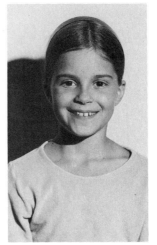

Direct flash off camera—*usually raised and to one side—gives more roundness and modeling than does flash on camera. A special extension (synchronization or synch) cord lets the flash be moved away from the camera. To avoid a shadow on the wall, move the subject away from it or raise the flash more.*

Flash bounced from the ceiling *onto the subject gives a softer, more natural light than does direct flash. Usually about 2 stops more exposure is needed than with direct flash from the same distance. Light can also be directed into an umbrella reflector and then bounced onto the subject.*

Flash bounced from a side wall *onto the subject gives a soft, flattering light. The closer the subject is to the wall, the more distinct the shadows on the subject will be. To avoid a shadow on the back wall, move the subject away from it.*

7 How to see like a camera

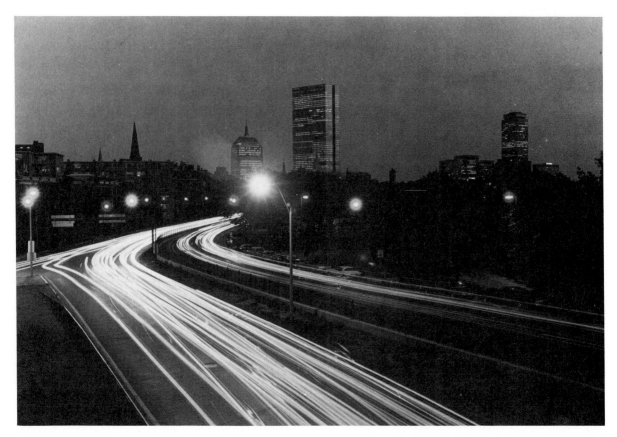

Pictures translate the world we see. If you have ever had a picture turn out to be different from what you anticipated, you know that the camera does not "see" the way a human sees. For example, in a black-and-white photograph the colors we see in the world are translated into shades of gray, but even color film does not record colors exactly the way the eye sees them, and a color print can alter colors even more.

The way we see contrast is also different from film's response. When we look at a contrasty scene, the iris of the eye continuously adjusts to different levels of brightness by opening up or closing down. In a photograph the contrast between very light and very dark areas is often too great for the film to record them both well in the same picture,

so they appear as overexposed and too light or underexposed and too dark. Motion, sharpness, and other elements also can be similar to what we see in the original scene, but never exactly the same.

The creative part of photography is that you can make choices among the ways that the camera and film translate a scene. You decide if you want the traffic to blur into a stream of lights. You decide if you want the snow to be blank white with shapes outlined against it. You decide if you want the leaves brightly lit against a solid black background. More about your choices—and how to make them —on the following pages.

Choices. *During an exposure of several seconds the headlights on moving automobiles made long streaks (opposite). A shorter exposure would have made the streaks shorter and the surrounding scene darker. At right, contrast was high: the snow was much brighter than the rest of the scene. To calculate the exposure the photographer metered just the person and let the bright snow go pure white. Less exposure would have made the whole scene darker, with the person silhouetted against grayish snow. Above, contrast was also high: the background was much darker than the leaves. With more light on the background or with more exposure, the background would have been visible and the leaves would not have stood out so strongly.*

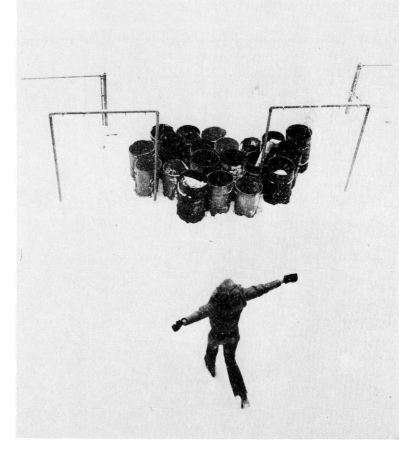

What's in the picture: The edges or frame

One of the first choices to make in a photograph is what to include and what to leave out. The image frame, the rectangle you see when you look through the viewfinder, shows only a section out of the much wider scene that is in front of you. The frame crops the scene—or rather *you* crop it—when you decide where to point the camera, how close to get to your subject, what angle to shoot at —in other words, what to include in your picture.

Decide before you shoot if you want to show the whole scene (or as much of it as you can) or if you want to move in close for a detail. You can focus attention on something by framing it tightly or you can step back and have it be just another element in an overall situation. When you look through the viewfinder, imagine you are viewing the final print or slide. This will help you frame the subject better. The tendency is to "see" only the subject and ignore its surroundings. In the final print, however, the surroundings and framing are immediately noticeable.

You can also change framing later by cropping the edges of a picture either when you print it yourself or if you send it to a lab to be printed, and many photographs can be improved by cropping out distracting elements at the edges of the frame. But if you are making slides, it is best to crop when you take the picture. Although you can duplicate a slide and change its cropping then, it's easier to frame the scene the way you want it when you shoot.

The edges of a picture, the frame, *surround and shape the image. Look around the edges at how the frame cuts into some objects or includes them entirely. How could different framings change these pictures?*

96

What is left out of a picture *can be as important as what is in it. The entire statue is not nearly as humorous as seeing just the cherub tagging along after Dad.*

What's in the picture: The background

Seeing the background. When you view a scene you see most sharply whatever you are looking at directly, and you see less clearly objects in the background or at the periphery of your vision. If you are concentrating on something of interest you may not even notice other things nearby. But the lens does see them, and it shows unselectively everything within its angle of view. Unwanted or distracting details can be ignored by the eye look-

ing at a scene, but in a picture they are evident. Photographing the background out of focus is one way to deal with a distracting background (see page 102), or you can change your angle of view, as in the photographs below. Strange and delightful juxtapositions that usually go unseen—except in a photograph—are one of the pleasures of photography, as in the picture opposite.

A distracting background of sun bathers and baby strollers are unnecessary elements in this portrait in the park. The tree directly behind the subject's head also draws the attention of the viewer.

A plainer and better background resulted from simply walking around to one side and changing the angle from which the subject was seen.

The sign in the background *adds an extra bit of humor to this scene of people dealing with their hot dogs. The camera records everything within its angle of view: if you start looking at the backgrounds of scenes as well as just the principal subject of interest, you may find some surprising combinations.*

Depth in a picture: Three dimensions become two

Photographs can seem to change the depth in a scene. When you translate the three dimensions of a scene that has depth into the two dimensions of a flat photograph, you can expand space so that objects seem very far apart, or you can compress space so that objects appear to be crowded close together. For example, compare the two photographs below. You can compress the buildings in a city (opposite) into flat planes to look almost as if they were pasted one on top of the other, or you can give them exaggerated height. Pages 34–35 explain more about how to control perspective effects like these that can change the way a photograph shows depth.

Two different focal length lenses *gave two very different versions of the same scene from the same position: a short-focal-length lens (top) expanded the space; a long-focal-length lens (bottom) compressed it. Neither of the lenses actually changed anything in the scene. The short-focal-length lens simply included nearby objects as well as those that were farther away. The part of the scene shown in the bottom photograph is exactly the same within the wider view of the scene shown in the top photograph.*

Two perspectives of the same city. *Buildings appear to tower to great heights when you look down on them (bottom). The closer any object is to your eye or to the camera, the bigger it appears to be, so the building looks larger at the top than at the bottom because the camera was closer to its top stories than to its bottom ones. Sections of buildings seen from the side seem to lie one right on top of the other (top). Clues that might indicate the actual space that exists between the buildings are all excluded from the scene.*

Depth of field: Which parts are sharp

We are usually not aware that we focus our eyes on only one distance at a time while all other distances are not as sharp. Our eyes automatically adjust their focus as we look from one object to another. You might look at the butterfly in the scene opposite and not notice that you are not seeing the girl just on the other side of the window as clearly as you see the butterfly. But in a photograph, differences in the depth of field (the sharpness of different objects) is immediately evident.

Controlling the depth of field. Sometimes you have no choice about depth of field: for example, in dim light or with slow film or under other conditions, the depth of field may have to be very shallow. But usually you can control the depth of field to some extent, as shown on pages 30–31. It is not necessarily better to have everything totally sharp or the background out of focus—or to follow any other rules, but it is important to remember that in the photograph you will notice what is sharp and what isn't.

Throwing the background out of focus *is one way to make a busy background less distracting. The eye tends to look first at the objects in a photograph that are the sharpest, and here the interesting part of the picture is the woman roping the calf, not the fence and the next corral in the background.*

The most important part of the picture is usually—but not always—the one that is focused most sharply. With the butterfly very sharp and the girl slightly out of focus, the relationship between the two of them is emphasized even more than if both of them had been equally sharp.

Landscapes are often photographed with everything sharp from foreground to background. The entire landscape is important, not any particular part of it. If you had been standing by the camera looking out over the hills when this picture was taken, each part of the scene would have looked sharp to you. You wouldn't have noticed that your eyes were actually focusing sharply first on one part of the scene, then on another.

Time and motion in a photograph

A photograph is a slice of time. Just as you select the section that you want to photograph out of a larger scene, you also can choose the section of time you want to record. You can think of a photograph as slicing through time, taking a wide slice during a slow shutter speed or a narrow slice at a fast shutter speed. In that slice of time things are moving, and, depending on the shutter speed, direction of the motion, and other factors discussed on pages 10–11, you can show objects frozen in mid-movement, blurred until they are almost unrecognizable, or blurred to any extent in between. How would you have photographed the rodeo scene (below)—sharp as it is or blurred to show the jolting of the bull? How about the dancers (opposite)—blurred and filmy or sharp and crisp to show their exact gestures and positions?

A fast shutter speed froze the motion of the bull, men, hat, and dust. With bright sunlight and a high film speed, the photographer was also able to use a small aperture so that everything is sharply focused from foreground to background.

A slow shutter speed *blurred the dancers' arms and torsos, which were moving, while their feet, which were relatively still, are sharper.* ►

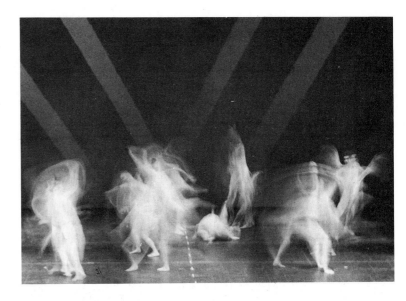

Panning, *moving the camera in the direction that the subject is moving, is another way to show motion. The moving subject is relatively sharp while the surrounding scene is blurred.* ▼

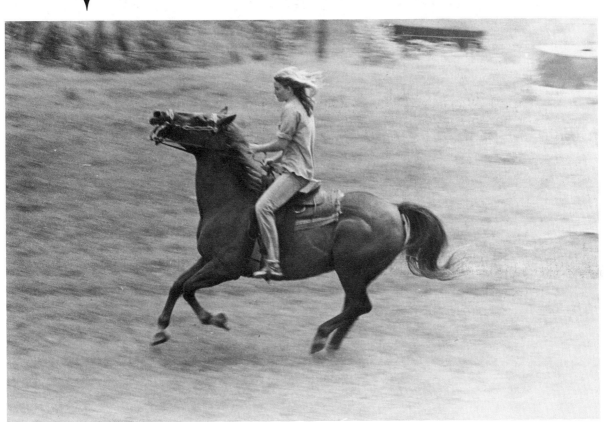

Photographing children: At their level

Children are probably the most photographed subject in the world, but all too often the photographer looks down on them from adult height. If you get down to child level by kneeling, sitting, or however you can, you and your photographs can participate more intimately in their world. It can also help to put children at ease if you and your camera don't loom over them but are at about their height.

Two children in clown makeup *for a street festival look disarmingly into the lens. In the photograph below, taking the picture at the girl's level lets the viewer share her fun in wandering through a forest of taller adults, safely attached to one of the trees.*

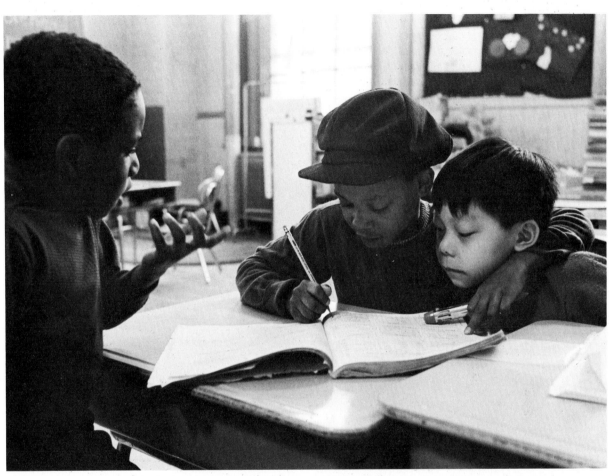

Sharing children's engrossment *in their projects often comes more easily if you are at their height. At school, they may be more receptive of your participation if you are not looking down at them from teacher level.*

Photographing children: While they are occupied

Photographing children when they are busy doing something besides being photographed is a good way to capture expressions that are natural and spontaneous. It pays to be familiar with the camera's controls so that you can operate them easily and quickly. Telling a child to "hold still" while you make last-minute adjustments is likely to produce a wooden smile at best.

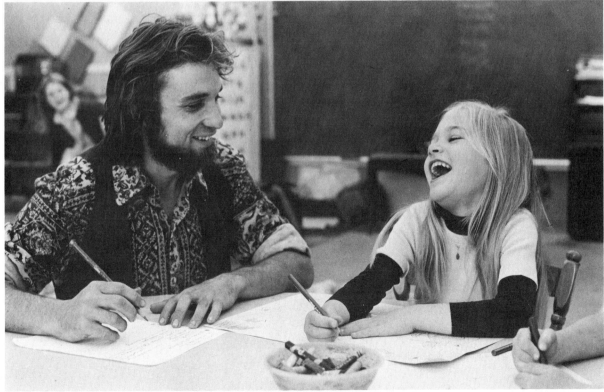

An environmental portrait

People—and animals—shape the space around them, and photographing them in their own environment—where they live or work or wherever they have established a corner of their own—can tell much more about them than just a straight head-and-shoulders portrait. How the subject sits or stands: proudly in command of his locomotive, quietly contemplative in her chair, or on a cold bench wondering what the vet will say—adds an extra dimension to their character and to the portrait.

Clockwise from right. *Four generations of a Vermont farm family pose in front of their dairy operation. The farm buildings and pasture, the work clothes and boots make the picture realistic and believable, as if the people had just stepped away from their chores.*

At the vet's, the man curves as protectively around the dog as does the blanket. Anyone who has ever waited for the doctor knows the feeling here.

The photographer Imogen Cunningham in a restful moment in her San Francisco home.

A railwayman, one hand possessively on his locomotive, stands at ease and confident, not in the slightest bit dwarfed by the big engine.

A Navajo woman displaying her turquoise and silver jewelry for sale has staked out a space that she possesses with great dignity.

110

Photographing the landscape/cityscape

How do you photograph a place? There are as many different ways to view a scene as there are photographers. Most important for you: what do you want to remember, what is the best part of the place for you? Did you like the arching view under the Eiffel Tower better than the tower seen from a distance? The priest trudging across a bridge in Rome rather than the fountains and statues? The quiet landscapes of New England instead of the cities? How does a place speak to you?

Paris. *The photographer underexposed this picture in order to silhouette the lacelike structure of the Eiffel Tower.*

Rome. *With the camera set on a tripod and the scene composed and focused, the photographer waited until an interesting subject walked through the scene.*

New England. *The photographer used a small aperture for these landscapes to increase depth of field so that the scenes are sharp from foreground to background. This meant that a relatively slow shutter speed had to be used. Only the bird (left) was moving fast enough to blur during the long exposures.*

Glossary

Prepared by Lista Duren

adapter ring A ring used to attach one camera item to another; for example, to attach a lens to a camera in reverse position in order to increase image sharpness when focusing very close to the subject.

angle of view The amount of a scene that can be recorded by a particular lens; determined by the focal length of the lens.

aperture The lens opening formed by the iris diaphragm inside the lens. The size is variable and is controlled by the aperture ring on the lens.

aperture-priority mode An automatic exposure system in which the photographer sets the aperture (f-stop) and the camera selects a shutter speed for correct exposure.

aperture ring The band on the camera lens that, when turned, adjusts the size of the opening in the iris diaphragm and changes the amount of light that reaches the film.

ASA A number rating that indicates the speed of a film. Stands for American Standards Association. See also **DIN.**

auto winder An accessory unit that attaches to the camera enabling motorized film advance.

automatic exposure A mode of camera operation in which the camera automatically adjusts the aperture, shutter speed, or both for proper exposure.

automatic flash An electronic flash unit with a light-sensitive cell that determines the length of the flash for proper exposure by measuring the light reflected back from the subject.

averaging meter An exposure meter with a wide angle of view. The indicated exposure is based on an average of all the light values in the scene.

base The supporting material that holds a photographic emulsion. For film, it is plastic or acetate. For prints, it is paper.

bellows An accordion-pleated section inserted between the lens and the camera body. In close-up photography the bellows allows closer-than-normal focusing resulting in an increased image size.

body The light-tight box that contains the camera mechanisms and protects the film from light until you are ready to make an exposure.

bounce light Indirect light produced by pointing the light source away from the subject and using a ceiling or other surface to reflect the light back toward the subject. Softer and less harsh than direct light.

bracketing Taking several photographs of the same scene at different exposure settings, some greater than and some less than the setting indicated by the meter, to ensure a well-exposed photograph.

built-in meter An exposure meter in the camera that takes a light reading (usually through the camera lens) and relays exposure information to the electronic controls in an automatic camera or to the photographer if the camera is being operated manually.

cable release An encased wire which attaches at one end to the shutter release on the camera and has a plunger on the other end that the photographer depresses to activate the shutter. Used to avoid camera movement or to activate the shutter from a distance.

cassette A light-tight metal or plastic container in which 35mm film is packaged.

center-weighted meter A through-the-lens exposure meter that measures light values from the entire scene but gives greater emphasis to those in the center of the image area.

close-up A larger-than-normal image obtained by using a lens closer than normal to the subject.

close-up lens An attachment placed in front of an ordinary lens to allow focusing at a shorter distance in order to increase image size.

color balance The overall accuracy with which the colors in a color photograph match or are capable of matching those in the original scene. Color films are balanced for use with specific light sources.

color temperature Description of the color of a light source by placing it on a numerical scale of degrees Kelvin.

compound lens A lens made up of several lens elements.

contrast The difference in brightness between the light and dark parts of a scene or photograph.

contrasty Having greater-than-normal differences between light and dark areas.

cool Toward the green–blue–violet end of the visible spectrum.

daylight film Color film that has been balanced to produce natural-looking color when exposed in daylight. Images will look reddish if daylight film is used with tungsten light.

depth of field The distance between the nearest and farthest points that appear in acceptably sharp focus in a photograph. Depth of field varies with lens aperture, focal length, and camera-to-subject distance.

diaphragm (iris diaphragm) The mechanism controlling the size of the lens opening and therefore the amount of light that reaches the film. It consists of several overlapping metal leaves inside the lens that form a circular opening of variable sizes. (You can see it as you look into the front of the lens.) The size of the opening is referred to as the f-stop or aperture.

diffused light Light that has been scattered by reflection or by passing through a translucent material. Produces an even, often shadowless, light.

DIN A number rating used in Europe that indicates the speed of a film. Stands for Deutsche Industrie Norm. See also **ASA.**

diopter Indicates the magnifying power of a close-up lens.

direct light Light shining directly on the subject and producing strong highlights and deep shadows.

directional/diffused light Light that is partly direct and partly scattered. Softer and less harsh than direct light.

electronic flash (strobe) A camera accessory that provides a brilliant flash of light. A battery-powered unit requires occasional recharging or battery replacement, but unlike a flashbulb can be used repeatedly.

emulsion A thin coating of gelatin, containing a light-sensitive material such as silver-halide crystals plus other chemicals, spread evenly on one surface of film or paper to record an image.

environmental portrait A photograph in which the person's surroundings are important to the portrait.

exposure 1. The act of allowing light to strike a light-sensitive surface. 2. The amount of light reaching the film, controlled by the combination of aperture and shutter speed.

exposure meter (light meter) An instrument that measures the brightness of light and provides aperture and shutter speed combinations for correct exposure. Exposure meters may be built into the camera or they may be separate instruments.

exposure mode The type of camera operation (such as manual, shutter priority, aperture priority) that determines which controls you set and which ones the camera sets automatically. Some cameras operate in only one mode. Others may be used in a variety of modes.

extension tubes Metal rings attached between the camera lens and the body to allow closer-than-normal focusing in order to increase the image size.

fill light A light source or reflector used to lighten shadow areas so that contrast is decreased.

film A roll or sheet of a flexible material coated on one side with a light-sensitive emulsion and used in the camera to record an image.

film advance lever A device, usually on the top of the camera, that winds the film forward a measured distance so that an unexposed segment moves into place behind the shutter.

film plane (focal plane) The surface inside the camera where the film rests during exposure and where the image is in sharp focus.

film speed The relative sensitivity to light of photographic film. Measured by ASA (or DIN) rating. Faster film (higher number) is more sensitive to light and requires less exposure than slower film.

filter A piece of colored glass or plastic placed in front of the camera lens to alter the quality of the light reaching the film.

filter factor A number, provided by the filter manufacturer, that tells you how much to increase exposure to compensate for the light absorbed by the filter. You usually don't have to be concerned with filter factors if your camera has a through-the-lens metering system.

fisheye lens An extreme wide angle lens covering a 180° angle of view. Straight lines appear curved at the edge of the photograph, and the image itself may be circular.

flare Stray light that reflects between the lens surfaces and results in a loss of contrast or an overall grayness in the final image.

flash 1. A short burst of light emitted by a flashbulb or electronic flash unit at the same time the film is exposed. 2. The equipment used to produce this light.

flashbulb A battery-powered bulb that emits one bright flash of light and then must be replaced.

flat Having less-than-normal differences between light and dark areas.

focal length The distance from the optical center of the lens to the film plane when the lens is focused on infinity. The focal length is usually expressed in millimeters (mm) and determines the angle of view (how much of the scene can be included in the picture) and the size of objects in the image. A 100mm lens, for example, has a narrow angle of view and magnifies objects by comparison to a lens of shorter focal length.

focal plane See **film plane**

focus 1. The point at which the rays of light coming through the lens converge to form a sharp image. The picture is "in focus" or sharpest when this point coincides with the film plane. 2. To change the lens-to-film distance (or the camera-to-subject distance) until the image is sharp.

focusing ring The band on the camera lens that when turned moves the lens in relation to the film plane, focusing the camera for specific distances.

focusing screen See **viewing screen**

frame 1. A single image in a roll of film. 2. The edges of an image.

fresnel An optical surface with concentric circular steps. Used in a viewing screen to equalize the brightness of the image.

f-stop (f-number) A numerical designation (f/2, f/2.8, etc.) indicating the size of the aperture (lens opening).

ghosting Bright spots in the picture the same shape as the aperture (lens opening) caused by reflections between lens surfaces.

grain The speckled effect caused by particles of silver clumping together in the negative.

guide number A number on a flash unit that can be used to calculate the correct aperture for a particular film speed and flash-to-subject distance.

hand-held meter An exposure meter that is separate from the camera.

hand hold To support the camera with the hands rather than with a tripod or other fixed support.

high-contrast film Film that records light tones lighter and dark tones darker than normal, thereby increasing the difference between tones.

hot shoe A clip on the top of the camera that attaches a flash unit and provides an electrical link to synchronize the flash with the camera shutter, eliminating the need for a sync cord.

hyperfocal distance The distance to the nearest object in focus when the lens is focused on infinity. Setting the lens to focus on this distance instead of on infinity will keep the farthest objects in focus plus extend the depth of field to include objects closer to the camera.

incident-light meter A hand-held exposure meter that measures the amount of light falling on the subject. See also **reflected-light meter.**

indoor film See **tungsten film**

infinity designated ∞. The farthest distance marked on the focusing ring of the lens, generally about 50 feet. When the camera is focused on infinity, all objects at that distance or farther will be sharp.

infrared film Film that is sensitive to wavelengths slightly longer than those in the visible spectrum as well as some wavelengths within the visible spectrum.

interchangeable lens A lens that can be removed from the camera and replaced by another lens.

iris diaphragm See **diaphragm**

latitude The amount of over- or underexposure possible without a significant change in the quality of the image.

LED See **light-emitting diode**

lens One or more pieces of optical glass used in the camera to gather and focus light rays to form an image.

lens cleaning fluid A liquid made for cleaning lenses without damaging the delicate coating on the lens surface.

lens coating A thin transparent coating on the surface of the lens which reduces light reflections.

lens element A single piece of optical glass that acts as a lens or as part of a lens.

lens hood (lens shade) A shield that fits around the lens to prevent extraneous light from entering the lens and causing ghosting or flare.

lens tissue A soft lint-free tissue made specifically for cleaning camera lenses. Not the same as eyeglass cleaning tissue.

light-emitting diode (LED) A display of colored lights in the viewfinder of some cameras that gives you information about aperture and shutter speed settings or other exposure data.

light meter See **exposure meter**

long-focal-length lens (telephoto lens) A lens that provides a narrow angle of view of a scene, including less of a scene than a lens of normal focal length and therefore magnifying objects in the image.

macro lens A lens specifically designed for close-up photography and capable of good optical performance when used very close to a subject.

macrophotography Production of images on film that are life-size or larger.

magnification The size of an object as it appears in an image. Magnification of the image on film is determined by the lens focal length. A long-focal-length lens makes an object appear larger (provides greater magnification) than a short-focal-length lens.

main light The primary source of illumination.

manual exposure A nonautomatic mode of camera operation in which the photographer sets both the aperture and the shutter speed.

match-needle metering A manual exposure mode in which the photographer adjusts the shutter speed and aperture until the camera's viewfinder shows (by matching two needles or by other indicators) that the film will be properly exposed.

matte Not shiny.

meter 1. See **exposure meter**. 2. To take a light reading with a meter.

mirror A polished metallic reflector set inside the camera body at a 45° angle to the lens to reflect the image up onto the focusing screen. When a picture is taken, it moves so that light can reach the film.

motor drive unit A camera accessory that automatically advances the film once it has been exposed.

negative 1. An image with colors or dark and light tones that are the opposite of those in the original scene. 2. Film that was exposed in the camera and processed to form a negative image.

negative film Photographic film that produces a negative image upon exposure and development.

neutral density filter A piece of dark glass or plastic placed in front of the camera lens to decrease the intensity of light entering the lens. It affects exposure, but not color.

normal-focal-length lens (standard lens) A lens that provides about the same angle of view of a scene as the human eye and that does not seem to magnify or diminish the size of objects in the image unduly.

open up To increase the size of the lens aperture. The opposite of stop down.

orthochromatic film Film that is sensitive to blue and green light but not red light.

overexposure Exposing the film to more light than is needed to render the scene as the eye sees it. Results in a too dark (dense) negative or a too light positive.

pan To move the camera during the exposure in the same direction as a moving subject. The effect is that the subject stays relatively sharp and the background becomes blurred.

panchromatic film Film that is sensitive to the wavelengths of the visible spectrum.

pentaprism A five-sided optical device used in an eye-level viewfinder to correct the image from the focusing screen so that it appears right side up and correct left to right.

perspective The illusion of a three-dimensional space suggested primarily by converging lines and the decrease in size of objects farther from the camera.

photoflood A tungsten lamp designed especially for use in photographic studios. It emits light at 3400°K and is suitable for use with tungsten Type A film.

photomicrography Photographing through a microscope.

polarizing screen (polarizing filter) A filter placed in front of the camera lens to reduce reflections from nonmetallic surfaces like glass or water.

positive An image with colors or light and dark tones that are similar to those in the original scene.

print An image (usually a positive one) on photographic paper, made from a negative or a transparency.

quartz lamp A tungsten lamp which has high intensity, small size, long life, and constant color temperature. Balanced for use with tungsten film.

reciprocity effect (reciprocity failure) A shift in the color balance or the darkness of an image caused by very long or very short exposures.

reflected-light meter An exposure meter (hand held or built into the camera) that reads the amount of light reflected from the subject. See also **incident-light meter.**

reflector Any surface—a ceiling, a card, an umbrella, etc.— used to bounce light onto a subject.

reversal film Photographic film that produces a positive image (a transparency) upon exposure and development.

reversal processing A procedure for producing a positive image on film (a transparency) from the film exposed in the camera or a positive print from a transparency with no negative involved.

rewind crank A device, usually on the top of the camera, for winding the film back into the cassette once it has been exposed.

shoe A clip on a camera for attaching a flash unit. See also **hot shoe.**

short-focal-length lens (wide-angle lens) A lens that provides a wide angle of view of a scene, including more of the subject area than a lens of normal focal length.

shutter A device in the camera that opens and closes to expose the film to light for a measured length of time.

shutter-priority mode An automatic exposure system in which the photographer sets the shutter speed and the camera selects the aperture (f-stop) for correct exposure.

shutter release The mechanism, usually a button on the top of the camera, that activates the shutter to expose the film.

shutter speed dial The camera control that selects the length of time the film is exposed to light.

silhouette A dark shape with little or no detail appearing against a light background.

single-lens reflex (SLR) A type of camera with one lens which is used both for viewing and for taking the picture. A mirror inside the camera reflects the image up into the viewfinder. When the picture is taken, this mirror moves out of the way, allowing the light entering the lens to travel directly to the film.

slide See **transparency**

SLR See **single-lens reflex**

spectrum The range of radiant energy from extremely short wavelengths to extremely long ones. The visible spectrum includes only the wavelengths to which the human eye is sensitive.

speed 1. The relative ability of a lens to transmit light. Measured by the largest aperture at which the lens can be used. A fast lens has a larger maximum aperture and can transmit more light than can a slow one. 2. The relative sensitivity to light of photographic film. See **film speed.**

standard lens See **normal-focal-length lens**

spot meter An exposure meter with a narrow angle of view, used to take a reading from a small portion of the scene being photographed.

stop 1. An aperture setting that indicates the size of the lens opening. 2. A change in exposure by a factor of two. Changing the aperture from one setting to the next doubles or halves the amount of light reaching the film. Changing the shutter speed from one setting to the next does the same thing. Either changes the exposure one stop.

stop down To decrease the size of the lens aperture. The opposite of open up.

stopped-down automatic exposure A mode of operation possible with some cameras. Ordinarily the camera meters the scene (and you view the scene) with the aperture wide open, stopping down to the proper aperture only when the picture is taken. In stopped-down exposure the camera meters the scene with the aperture already stopped down.

strobe See **electronic flash**

substitution reading An exposure meter reading taken from something other than the subject, such as from a gray card of standard darkness or the photographer's hand.

sync (or synchronization) cord An electrical wire that links a flash unit to a camera's shutter release mechanism.

synchronize To cause a flash unit to fire while the camera shutter is open.

telephoto lens See **long-focal-length lens**

35mm The width of the film used in all the cameras described in this book.

through-the-lens meter (TTL meter) An exposure meter built into the camera which takes light readings through the lens.

transparency (slide) A positive image on a clear film base viewed by passing light through from behind with a projector or light box. Usually in color.

tripod A three-legged support for the camera.

TTL Abbreviation for through the lens, as in through-the-lens viewing or metering.

tungsten film Color film that has been balanced to produce natural looking color when exposed in tungsten light. Images will look bluish if tungsten film is used in daylight.

tungsten film Type A Color film that will produce natural looking color when used with bulbs with a color temperature of 3400°K.

tungsten film Type B Color film that will produce natural looking color when used with bulbs with a color temperature of 3200°K.

umbrella reflector An apparatus constructed like a parasol with a reflective surface on the inside. Used to bounce or diffuse light onto a subject.

underexposure Exposing the film to less light than is needed to render the scene as the eye sees it. Results in a too light (thin) negative or a too dark positive.

viewfinder eyepiece An opening in the camera in which the scene to be photographed is visible to the photographer.

viewing screen The surface on which the image in the camera appears for viewing. This image appears upside down and reversed left to right unless the camera contains a pentaprism to correct it.

vignette To shade the edges of an image so they are underexposed. A lens hood that is too long for the lens will cut into the angle of view and cause vignetting.

visible spectrum See **spectrum**

warm Toward the red–orange–yellow end of the visible spectrum.

wide-angle distortion Unusual changes in perspective or in the appearance of objects caused by using a wide-angle (short-focal-length) lens very close to the subject.

wide-angle lens See **short-focal-length lens**

zone focusing Presetting the focus to photograph action so that the entire area in which the action may take place will be sharp.

zoom lens A lens with several moving elements which can be used to produce a continuous range of focal lengths.

Bibliography

Curtin, Dennis and Joe DeMaio. *The Darkroom Handbook: A Complete Guide to the Best Design, Construction, and Equipment.* Marblehead, Mass.: Curtin & London, Inc., 1979.

Eastman Kodak Co. publishes many books and pamphlets of interest to photographers. Only a few are listed here. For a free *Index to Kodak Information* (L-5) write to Eastman Kodak Co., 354 State Street, Rochester, N.Y. 14650 or to Kodak Ltd., Kodak House, Station Road, Hemel Hempstead, Hertfordshire HP1 1JU, England. Their publications are available in camera stores or directly from Kodak.
Adventures in Color-Slide Photography (AE-8), 1975.
Adventures in Existing-Light Photography (AC-44), 1976.
How to Make Good Pictures (AW-1), 1975.
Indoor Picture-Taking (AC-31), 1974.

Focal Encyclopedia of Photography. New York: McGraw-Hill Book Company, 1971.

Gernsheim, Helmut and Alison Gernsheim. *A Concise History of Photography.* New York: Grosset and Dunlap, Inc., 1965.

Hattersley, Ralph. *Beginner's Guide to Photography.* Garden City, N.Y.: Doubleday & Co., Inc., 1974.

Hedgecoe, John. *The Art of Color Photography.* New York: Simon & Schuster, Inc., 1978.

Hedgecoe, John. *The Photographer's Handbook.* Alfred A. Knopf, Inc., 1978.

Jacobs, Lou, Jr. *Photography Today for Personal Expression.* Santa Monica, Calif.: Goodyear Publishing Co., Inc., 1976.

Life Library of Photography. New York: Time-Life Books, 1970–79. Seventeen volumes plus yearbooks.

Newhall, Beaumont. *The History of Photography.* New York: The Museum of Modern Art, 1964.

Patterson, Freeman. *Photography for the Joy of It.* Toronto: Van Nostrand Reinhold Ltd., 1977.

Stone, Jim. *Darkroom Dynamics: A Guide to Creative Photographic Techniques.* Marblehead, Mass.: Curtin & London, Inc., 1979.

Sussman, Aaron. *The Amateur Photographer's Handbook.* New York: Thomas Y. Crowell, Inc., 1973.

Szarkowski, John. *Looking at Photographs.* New York: The Museum of Modern Art, 1973.

Upton, Barbara and John Upton. *Photography.* A text adapted from the Life Library of Photography. Boston: Little, Brown & Co., 1976.

Periodicals

Amateur Photographer, Surrey House, 1 Throwley Way, Sutton, Surrey SM1 4QQ, England.

American Photographer, 485 Fifth Avenue, New York, N.Y. 10017.

Aperture, Elm Street, Millerton, N.Y. 12546.

Camera, C. J. Bucher Ltd., Lucerne, Switzerland.

Camera 35, Popular Publications, 150 East 58th Street, New York, N.Y. 10022.

Camera User Magazine, Link House, Dingwall Avenue, Croyden CR9 2TA, England.

Creative Camera, 19 Doughty Street, London WC1N 2PT, England.

Modern Photography, 130 East 59th Street, New York, N.Y. 10022.

Petersen's Photographic, 8490 Sunset Boulevard, Los Angeles, Calif. 90069.

Photo Technique, P.O. Box 4, Chepstow, Gwent, England.

Photography Magazine, 85 High Street, Hemel Hempstead, Hertfordshire, England.

Popular Photography, One Park Avenue, New York, N.Y. 10016.

Practical Photography, Park House, 117 Park Road, Peterborough PE1 2TS, England.

SLR Camera, Regent House, 54-62 Regent Street, London W1A 4YJ, England.

35mm Photography, Ziff-Davis Publ. Co., One Park Avenue, New York, N.Y. 10016.

Guide to Minolta equipment and accessories

Minolta's first camera. *The Nifcalette vest-pocket folding camera introduced in 1929.*

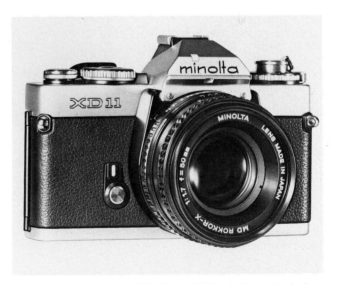

Minolta's XD-11. *A 35mm single-lens reflex compact camera featuring multi-mode automatic exposure. The world's first multi-mode camera.*

Minolta cameras:
The XD series

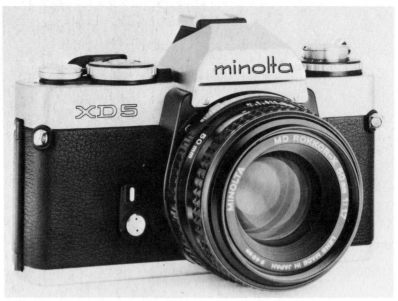

The XD-5 features a compact size, your choice in exposure modes, plus special accessories such as the Auto Winder D (shown opposite), the Auto Electroflash 200X and other dedicated flash units (shown on page 128), and the Data Back D (shown on page 133).

Metering system. Center weighted to give more importance to values at the center of the image. The fast response of the silicon photo diode (SPD) cell guarantees accurate readings even if your subject moves from bright light to dim shadows.

Automatic exposure: aperture priority. You set the aperture and the automatic exposure mechanism sets the stepless shutter speed. Useful when depth of field is more important than a particular shutter speed —for example, in a landscape that you want to be sharp from foreground to background. A depth-of-field preview button is provided.

Automatic exposure: shutter priority. You set the shutter speed (so the action is frozen sharply, completely blurred, or somewhere in between) and the camera selects the aperture. A good choice when photographing action. The camera automatically changes the shutter speed for correct exposure if you ignore over- or underexposure warning signals in the viewfinder.

Metered manual exposure. You set both aperture and shutter speed. The viewfinder displays suggested settings.

Automatic exposure override. In back-lit or other special lighting situations you may want to override the automatic exposure system. By making one simple camera adjustment you can automatically give each shot up to 2 stops additional exposure to lighten the picture or 2 stops less exposure to darken it.

Shutter. The metal-bladed electronic shutter travels vertically during exposure. It provides stepless shutter speeds from 1 sec to 1/1000 sec in aperture-priority mode and the same speed range in normal steps in shutter-priority and manual modes.

Shutter release. The electromagnetic design provides smooth, frictionless control, operating with a minimum of pressure. The shutter release is also the camera on/off switch and activates the metering system when depressed partway.

Lenses. Operation is fully automatic with all Rokkor-X lenses designated MD. Lenses without the MD designation will not activate the shutter-priority mode properly.

Flash hot shoe. The bracket on the top of the camera's pentaprism accepts all standard shoe-mount flash units. No cord connection is needed if the flash is designed for hot-shoe use. With a dedicated flash such as the Auto Electroflash 200X, the hot shoe automatically connects special camera controls that set the shutter speed to synchronize with flash and provide a flash ready-light in the camera's viewfinder.

Batteries. Powered by two 1.5V batteries. When the batteries run low, the LED indicators in the viewfinder begin to dim. When the batteries are completely exhausted, the camera

continues to operate with two mechanical shutter speeds: "X" (1/100 sec) and "B" for time exposures.

The XD-5 viewfinder *gives an extremely bright view of the scene, and a split-image/microprism focusing spot at the center of the finder aids fast, accurate focusing. In aperture-priority and metered-manual modes an LED dot indicates the shutter speed.*

In shutter-priority mode *the aperture is indicated. Under- and overexposure and flash-ready signals are also provided.*

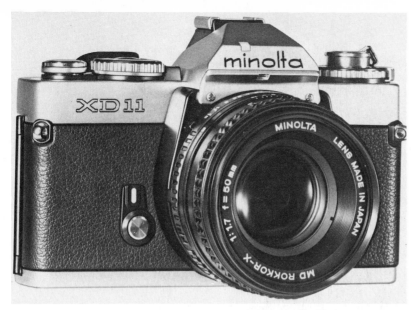

Auto Winder D. *If you would rather focus your attention entirely on your subject instead of stopping after each shot to wind the film, you will find an auto winder a useful accessory. With the winder in place you press the camera's shutter release and let go. The winder advances the film immediately after the exposure so you are always ready for the next picture. If you keep your finger on the shutter release, the shutter continues exposing and the film continues advancing at up to about 2 frames per second until the unit stops automatically at the end of the film. The winder is an integral part of its camera system so there are no caps or covers to remove in order to attach it. Shown here is the XD-11 with Auto Winder D in place; this winder can also be used with the XD-5.*

The XD-11* is very similar to the XD-5: compact in size, with multi-mode exposure controls. All the accessories usable with the XD-5 are also accepted by the XD-11, such as the Auto Winder D (shown at right), the Auto Electroflash 200X and other dedicated flash units (shown on page 128), and the Data Back D (shown on page 133). In addition to all the characteristics of the XD-5 described opposite, the XD-11 offers these extra features:

*Known as the XD-7 or XD in certain market areas.

Extra viewfinder information. As shown below, the XD-11 has two additional windows at the bottom of the viewfinder so that full exposure information is displayed in every operating mode.

A safe-load signal shows if film is loaded in the camera and if the film is advancing properly.

A built-in eyepiece blind prevents stray light from entering the viewfinder and affecting automatic exposures if you are not viewing the subject through the finder. (An external eyepiece cap is provided with the XD-5 to serve the same purpose.)

The XD-11 viewfinder *gives full exposure information in each of its operating modes, plus under- and overexposure warnings and a flash-ready light.*

Aperture-priority: *An LED dot indicates the shutter speed at the right of the viewfinder; the preselected aperture is shown at the bottom.*

Shutter priority: *An LED dot indicates the aperture at right; the preset minimum lens aperture and the preselected shutter speed are shown at bottom.*

Metered manual: *The preset aperture and shutter speed appear at bottom; as you change aperture, an LED indicates at right which shutter speed will provide normal exposure.*

Minolta cameras: The XG series

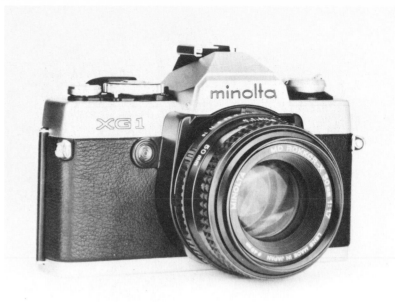

The XG-1 is compact in size, offering aperture-priority automatic exposure plus manual control, as well as special accessories such as the Auto Winder G (at right) and the Auto Electroflash 200X or other dedicated flash units (page 128).

Metering system. Center weighted for increased sensitivity to values at the center of the picture. Two cadmium sulphide (CdS) cells provide dependable, fast response to changes in light.

Automatic exposure: aperture priority. You select the aperture and the camera's automatic exposure mechanism sets the correct stepless shutter speed.

Manual exposure. You select both the aperture and shutter speed.

Automatic exposure override. Up to 2 stops additional exposure or 2 stops less exposure can be automatically given when you want to bracket your exposures or otherwise override the camera's automatic controls.

Shutter. An electronically controlled, rubberized cloth shutter travels horizontally during exposure. The shutter provides stepless speeds from 1 sec to 1/1000 sec in automatic exposure operation and the same speed range in normal steps in manual mode. The shutter release locks if the automatic exposure system indicates a shutter speed faster than 1/1000 sec.

Shutter release. The electromagnetic shutter release uses a "touch switch" to activate the camera's electronic circuitry with just a touch of your finger.

Lenses. All Minolta lenses can be mounted without modification for automatic or manual operation.

Flash hot shoe. Located on the top of the camera's pentaprism, the shoe accepts all standard shoe-mount flash units. No cord connection is needed if the flash is designed for hot-shoe use. With a dedicated flash such as the Auto Electroflash 200X, the hot shoe automatically connects special camera controls that set the shutter speed to synchronize with flash and provide a flash ready-light in the camera's viewfinder.

Batteries. Two 1.5V batteries supply all power to the camera's mechanisms.

The **XG-1 viewfinder** has a very bright image for viewing and focusing. A split-image/microprism center spot makes focusing quick and easy. To the right appears a shutter speed scale; a red LED lights alongside the shutter speed being set automatically (1 sec through 1/15 sec is indicated by a single LED dot). The viewfinder also displays under- and over-exposure warning signals and a flash-ready light.

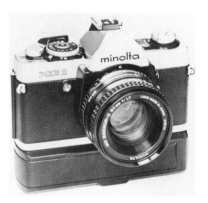

Auto Winder G. With the Auto Winder G in place on any XG camera you can shoot sequences at about 2 frames per second or take individual shots. When you press the camera's operating button, the winder immediately advances the film after the shutter closes so that you are instantly ready for the next picture. Holding down the operating button exposes and advances the film continuously. The winder attaches quickly to the tripod socket of the camera and all electronic connections are made automatically. Shown here is the XG-1 with Auto Winder G attached; this winder can also be used with the XG-7 or XG-9.

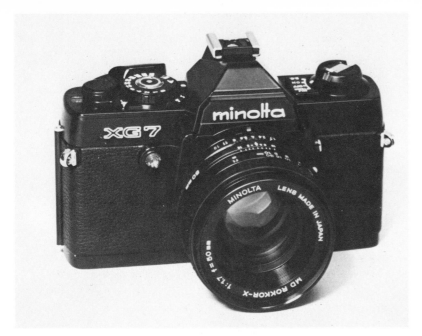

The XG-7 viewfinder *features a split-image/microprism center spot for fast focusing, plus an overall fresnel screen for bright, high-contrast viewing and composing. To the right appears the camera's shutter speed scale plus a red dot by the shutter speed being set in the automatic exposure mode. Two red flashing triangles warn against over- or under-exposure; with the Auto Electroflash 200X (or other dedicated flash units), a dot blinks next to 1/60 sec when the flash is charged and ready to fire.*

The XG-7* is very similar to the XG-1: compact in size with aperture-priority automatic exposure plus manual control. It accepts the Auto Winder G (shown opposite), the Auto Electroflash 200X and other dedicated flash units (page 128), and the Data Back G (page 133). In addition to all the features of the XG-1 described opposite, the XG-7 offers these extras:

Additional information in viewfinder. As shown at right, the XG-7 viewfinder displays a detailed shutter speed scale with the speed indicated by ten LED dots.

A memo holder on the back of the camera holds the end of a film box as a reminder of the type of film you are using.

A removable back makes it possible for the camera to accept the Data Back G.

Black-body finish. The XG-7 is shown here in a black-body finish. XD-11, XG-9, and XG-7 cameras are available in either a chrome-and-black or all-black finish. The black-body cameras are identical in all other respects to the regular models.

*Known as the XG-2 or XG-E in certain market areas.

The XG-9 has all the features of the XG-7: compact body, aperture-priority automatic exposure plus manual control. It accepts the Auto Winder G (shown opposite), the Auto Electroflash 200X and other dedicated flash units (page 128), and the Data Back G (page 133). In addition, it offers

Extra-bright viewfinder. Like the XD-11 viewfinder, an acute matte field makes the XG-9's viewfinder extremely bright.

Full exposure information in viewfinder. Similar to the XG-7 viewfinder shown above with shutter speed indicated by ten LED dots. In addition, the preset f-number appears at the bottom of the finder.

A depth-of-field preview button permits you to stop down the lens so that you can preview the depth of field in the final picture.

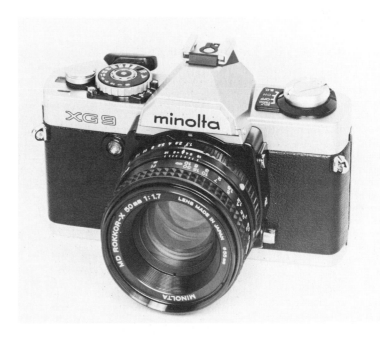

Minolta cameras:
The XK Motor/The SR-T series

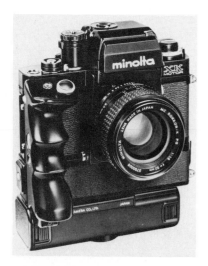

The XK Motor (known as the XM or X-1 Motor in certain markets) is designed exclusively for motor-drive photography. It offers automatic exposure; interchangeable finders, focusing screens, and battery packs; plus other features and accessories.

Motor Drive. The permanently attached motor provides single-frame and continuous-run film advance at rates up to 3.5 frames per second. A film-tension sensing mechanism automatically stops the advance at the end the film. Film rewind is also motor driven.

The AE-S Finder, shown in place on the XK Motor, is designed specifically for this camera, but is also compatible with older model nonmotorized XK cameras. It consists of an eye-level pentaprism with built-in metering and automatic exposure circuitry.

Automatic exposure: aperture priority. You select the aperture and the camera automatically selects the correct shutter speed at motor drive rates as high as 3.5 exposures per second.

Manual exposure. You can select both aperture and shutter speed if you wish.

Metering system. Center weighted to favor values at the center of the image. The fast response of the silicon photo cell (within 1/100,000 sec) enables the XK Motor to calculate film speed, lens aperture, and light measurement information and set the correct shutter speed at the full motor-drive rate of 3.5 fps.

Anatomical grip. Contoured for secure, comfortable holding, the grip incorporates a Senswitch that turns on the exposure system in response to fingertip pressure. An electromagnetic operating button releases the shutter and triggers motorized advance. A rotating lock ring prevents accidental operation.

Shutter. In automatic mode, the AE-S finder adjusts stepless shutter speeds ranging from 8 sec to 1/2000 sec. In manual operation, stepped shutter speeds may be set from 1 sec to 1/2000 sec. A long-exposure selector permits speeds from 2 sec to 16 sec. The shutter is constructed of titanium foil and maintains reliability even with repeated use in extreme heat, cold, and humidity.

Interchangeable battery packs. Power for the XK Motor is supplied by 10 AA-size (penlight) batteries, enough for advancing and rewinding approximately 20 to 80 36-exposure film cartridges depending on the framing rate.

The Standard Battery Pack (shown on the XK Motor above) attaches beneath the motor-drive housing.

The Separate Battery Pack (not shown) holds the batteries in a compact flat case that can be hung from a belt loop or carried in a jacket pocket. This pack connects to the camera by a power cord.

The Battery Grip (shown on the XK Motor with the 250-Frame Film Back) holds the batteries, plus doubles as a vertical hand grip. This unit has a button that can be used to trigger the motor drive.

The 250-Frame Film Back *allows you to make 250 exposures before you have to reload film, useful if you want to shoot long, rapid-fire sequences, ensure uninterrupted coverage of fast-moving events, or set up an unattended camera for instrumentation recording or similar work. When this back is used, motor-drive power must be provided by the Battery Grip (shown here) or the Separate Battery Pack; the Standard Battery Pack cannot be used. The back locks on the camera in place of the removable standard back; a frame counter and film cutter are built in. A film loader is available for quick loading of the removable film cartridges that hold the film.*

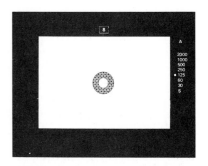

Viewfinder readout. *Full exposure information appears at the edges of the viewfinder image. In automatic mode the letter A appears above a dual-range shutter speed scale (high range shown here). An LED dot appears next to the automatically selected shutter speed with the preselected aperture shown at the top of the viewfinder.*

Viewfinders are interchangeable on the XK Motor if you want to replace the AE-S Finder that is normally supplied. *The Plain Finder (not shown) can be used if a built-in light metering system is not required—for example, by a studio photographer who primarily uses electronic flash.*

The High-Magnification Finder *magnifies the entire field of view 6.2 times, useful in close-up work or whenever extremely critical focusing is needed. The finder has a rubber-cushioned eyepiece and built-in adjustment (+3 to -5 diopters) for individual eyesight. This finder has no exposure meter and reverses the viewing image left to right.*

The Waist-Level Finder *is useful when eye-level viewing is difficult—for example, when the camera is placed very low to the ground. The folding hood springs up, and a magnifier swings up for critical focusing. The finder has no exposure meter and reverses the viewing image left to right.*

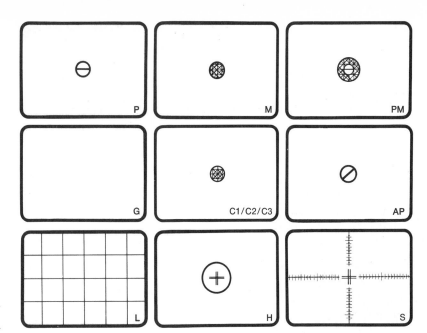

Focusing screen. *A Type PM focusing screen is provided with the camera. This matte fresnel screen with split-image/microprism central spot gives bright viewing plus fast focusing. The focusing screen can be interchanged with any of those shown here.*

For general photography: Type P—matte fresnel with split-image rangefinder spot; Type M—matte fresnel with microprism spot; Type PM—matte fresnel with split-image plus microprism; Type G—matte fresnel only; Types C1/C2/C3—clear fresnel with microprism; Type AP—fine-ground matte fresnel with diagonal split-image spot, provides a very bright image. For precise alignment: Type L—matte fresnel with etched grid. For high-magnification work: Type H—matte fresnel with clear circle and cross mark; Type S—clear fresnel with central cross plus measuring scales.

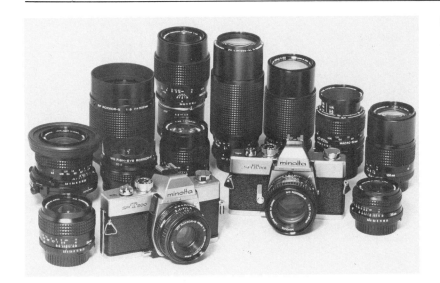

SR-T single-lens reflex cameras have built-in through-the-lens meters with exposures set by match-needle operation. Shown at left is the economical SR-T 200 (known in certain markets as the SR-T 100b). At right is the SR-T 201 (also known as the SR-T 101b).

Match-needle metering. Two built-in cadmium sulfide (CdS) cells measure the brightness of the light. The correct exposure is set by adjusting the lens diaphragm and/or shutter speed to align a needle visible in the viewfinder.

Minolta lenses and filters

Rokkor-X lenses are manufactured to meet the most rigorous photographic standards. Minolta makes them in its own factories, and rigid quality control is exercised over every step in design and manufacture. The lenses feature Minolta's patented Achromatic multi-layer coating for the finest color rendition and image contrast.

Minolta/Celtic lenses are coated to minimize reflections and improve color rendition. They offer high quality, reliability, and an economical price.

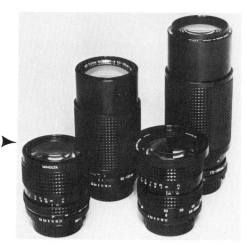

Special-purpose lenses in the Rokkor-X line include 400mm f/5.6 and 600mm f/6.3 MD Apo Telephoto Lenses with 2X Converter. *These lenses are small and lightweight for their focal lengths and are well suited for sports, news, wildlife, and other long-lens photography that requires extremely sharp definition.*

They incorporate a lens element made of fluorite which reduces chromatic aberrations to such an extent that the lenses are apochromatic, that is, yielding extremely high image sharpness. To expand their usefulness a 2X converter is available that doubles the focal length of the lenses to 800mm and 1200mm, respectively.

A zoom lens *gives you a range of focal lengths within the same lens, as illustrated on page 28. This means you can quickly frame the subject just the way you want it—larger or smaller within the image area. Shown left to right are four Minolta zoom lenses: 35–70mm f/3.5, 50–135mm f/3.5, 24–50mm f/4, and 75–200mm f/4.5.*

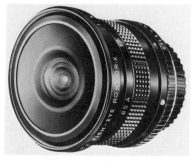

A fisheye lens *gives a dramatic 180° view of the world. The 7.5mm f/4 fisheye lens shown here produces a circular image like the one on page 29. The 16mm f/2.8 fisheye fills the entire frame from corner to corner with a curved perspective of the scene instead of a circular image in the center of the frame.*

Minolta filters

Minolta makes its own solid glass filters to the highest optical and mechanical standards. The filters are made in different sizes to fit the diameters of Minolta lenses. Information about the effects of various filters on color and black-and-white film appears on pages 72-73.

Filter	40.5	46	49	52	55	62	67	72
Yellow	•	•	•	•	•	•	•	•
UV Haze	•	•	•	•	•	•	•	•
Neutral Density 4X		•	•	•	•			•
Red			•	•	•			
Orange			•	•	•			•
Green			•	•	•			
1A Skylight			•	•	•		•	•
80B		•	•	•	•			•
85 (Type A)			•	•	•			•
Polarizing			•	•	•			

Sizes (in mm)

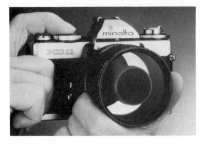

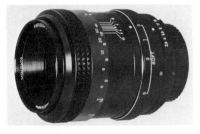

A catadioptric lens *(also called a mirror lens) uses a combination of mirrors and lenses to form the image. This type of lens is very light and compact when compared to a lens of the same focal length that does not have a mirror design. Shown here is Minolta's 250mm f/5.6 lens, no wider than and only ½ in longer than the compact 50mm lens.*

A Varisoft lens *is designed so that you can introduce controllable optical aberrations into the image. By doing so you can vary the image from very sharp to very soft. Minolta's 85mm f/2.8 Varisoft lens is shown here.*

A shift lens *is useful in architectural photography and other situations where control of perspective is needed. The lens can be shifted to include more of a subject without tilting the camera and so it avoids introducing apparent distortions in perspective. The 35mm f/2.8 shift lens is shown here.*

Rokkor-X lens specifications

Lens	Angle of view	Minimum focus	Minimum f-stop	Filter diameter
7.5mm f/4 MD Fisheye	180°	1.6 ft.(fixed)	f/22	Built in
16mm f/2.8 MD Fisheye	180°	1 ft.	f/22	Built-in
17mm f/4 MD	104°	.8 ft.	f/22	72mm
20mm f/2.8 MD	94°	.8 ft.	f/22	55mm
24mm f/2.8 MD VFC	84°	1 ft.	f/22	55mm
24mm f/2.8 MD	84°	1 ft.	f/22	55mm
28mm f/2 MD	75°	1 ft.	f/22	55mm
28mm f/2.8 MD	75°	1 ft.	f/22	49mm
35mm f/1.8 MD	63°	1 ft.	f/22	49mm
35mm f/2.8 Shift CA	63°	1 ft.	f/22	55mm
35mm f/2.8 MD	63°	1 ft.	f/22	49mm
45mm f/2 MD	51°	2 ft.	f/16	49mm
50mm f/1.4 MD	47°	1.5 ft.	f/16	49mm
50mm f/1.7 MD	47°	1.5 ft.	f/16	49mm
50mm f/1.2 MD	47°	1.5 ft.	f/16	55mm
85mm f/2 MD	29°	2.8 ft.	f/22	49mm
100mm f/2.5 MD	24°	3.3 ft.	f/22	55mm
135mm f/2.8 MD	18°	5 ft.	f/22	55mm
135mm f/3.5 MD	18°	5 ft.	f/22	55mm
200mm f/2.8 MD	12°30′	5.9 ft.	f/32	72mm
200mm f/4 MD	12°	8.2 ft.	f/22	55mm
250mm f/5.6 RF	10°	8.2 ft.	f/11 ND filter	Internal
300mm f/4.5 MD	8°10′	9.8 ft.	f/32	72mm
300mm f/5.6 MD	8°10′	15 ft.	f/32	55mm
400mm f/5.6 MD Apo Tele	6°	16 ft.	f/32	72mm
500mm f/8 RF	5°	13 ft.	f/16 ND Filter	Special Internal
600mm f/6.3 MD Apo Tele	4°10′	16.5 ft.	f/32	Special Internal
800mm f/8 RF	3°	26 ft.	f/16 ND Filter	Special Internal
1600mm f/11 RF	1°30′	70ft.	f/22 ND Filter	Special Internal
24–50mm f/4 MD Zoom	84°–47°	2.3 ft.	f/22	72mm
35–70mm f/3.5 MD Zoom	63°–34°	3.3 ft.	f/22	55mm
50–135mm f/3.5 MD Zoom	47°–18°	5 ft.	f/22	55mm
75–200mm f/4.5 MD Zoom	32°–12°30′	4 ft.	f/22	55mm
100–200mm f/5.6 MD Zoom	24°–12°30′	8 ft.	f/22	55mm
100–500mm f/8 MD Zoom	24°–5°	8 ft.	f/32	72mm
50mm f/3.5 MD Macro	47°	.8 ft.	f/22	55mm
100mm f/3.5 MD Macro	24°	1.5 ft.	f/22	55mm
85mm f/2.8 Varisoft	29°	2.6 ft.	f/16	55mm
100mm f/4 Auto Bellows	24°	—	f/32	55mm

Minolta/Celtic lens specifications

Lens	Angle of view	Minimum focus	Minimum f-stop	Filter diameter
28mm f/2.8 MC	75°	1 ft.	f/22	49mm
135mm f/3.5 MC	18°	5 ft.	f/22	55mm

Minolta electronic flash units

Minolta has an electronic flash to meet your needs whether you want a powerful professional unit, a smaller automatic flash, or a very lightweight and compact one. More information about flash and how to use it appears on pages 90–93. The features of Minolta flash units listed in the chart opposite are explained below.

The guide number for a flash is a measurement of its power. The higher the guide number for a given film speed (ASA), the brighter the flash and the farther you can use it from a subject.

An automatic flash unit makes flash photography easy. Within the range of distances that the unit covers, you just focus and shoot. A photoelectric sensor regulates the length of the flash for exposure. All the flash units listed in the chart are automatic except for the Electroflash 20.

Aperture choices with flash increase the range of distances within which you can use the flash in its automatic mode. The choice of apertures is also useful if you want to control depth of field in a particular shot.

Recycling time is the length of time it takes to recharge the unit for the next flash after a picture has been taken. If you want to take flash shots in quick succession, as with a power winder, you will want a flash unit capable of a short recycling time.

Thyristor (energy-saving) circuitry gives you shorter recycling times between shots as well as longer battery life.

Special camera controls are provided by any Minolta flash with "X" in its name (for example the 200X) when it is connected to an XG or XD camera. These dedicated units elec-

tronically set the camera's shutter to the correct speed for synchronization with flash. When the flash is fully charged, a flash-ready LED blinks in the camera's viewfinder.

A flash distance checker (FDC) lights up after a flash shot to confirm sufficient light output for correct exposure. It operates with either direct or bounce flash.

Angle of coverage. Most Minolta units illuminate an area as wide as that seen by a 35mm focal length lens, so they can be used with any lens of 35mm or longer focal length. The shorter the focal length of the camera lens, the wider the angle that the flash must illuminate if the picture is to be evenly lit. Some units have a wide angle diffuser that fits over the light to broaden its coverage.

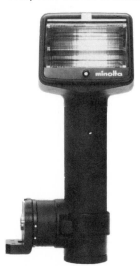

The Auto Electroflash 450 is a powerful unit that is fully automatic at any of five lens f-stops and can be operated in manual mode as well. Accessories are available such as the adjustable camera bracket shown above and a separate sensor for automatic bounce flash operation.

The Auto Electroflash 132X is a clip-on unit with a head that can be tilted upwards for bounce flash. The unit operates automatically even with bounce because the flash sensor (the small circular opening at the bottom of the unit) is separate from the head. The Auto Electroflash 128 is similar to the 132X. The Auto Electroflash 280, 320 and 320X have heads that move to either side as well as upwards.

The Auto Electroflash 200X is a clip-on automatic or manual flash that is especially designed for use with XD and XG cameras. Sliding the 200X into the hot shoe on one of these cameras automatically switches the camera's shutter to the correct synchronization as soon as the flash is fully charged. At the same time, the viewfinder signals that the flash is ready to fire. The unit can synchronize flash shots with an auto winder at the rate of up to 2 frames per second.

Flash specifications

	Maximum guide number (ASA 100 film)	Auto working range	Selectable auto apertures (ASA 100 film)	Auto bounce capability	Recycling time*	Thyristor (energy-saving) circuitry	Flash distance checker (FDC)	Angle of coverage (lens focal length that is fully lit)
Auto Electroflash 450	45 (distance to subject measured in meters)	16–0.5 m	f/2.8–f/11	with separate sensor	0.3–23 sec	Yes	No	50mm or longer
	148 (distance measured in feet)	(52–1.6 ft)						To 24mm with wide-angle diffuser
Auto Electroflash 320/320X	32 (meters)	11–0.7 m	f/2.8, f/5.6, f/11	with adjustable head	0.3–8 sec	Yes	Yes	35mm or longer
	105 (feet)	26–2.3 ft)						to 24mm with wide-angle diffuser
Auto Electroflash 280	28 (meters)	7–0.7 m	f/4–f/11	with adjustable head	0.5–11 sec	Yes	No	35mm or longer
	92 (feet)	(23–2.3 ft)						
Auto Electroflash 200X	20 (meters)	7–0.7 m	f/2.8, f/5.6	—	0.3–6 sec	Yes	No	35mm or longer
	66 (feet)	23–2.3 ft)						To 28mm with wide-angle diffuser
Auto Electroflash 132X	32 (meters)	8–0.7 m	f/4, f/8	with adjustable head	8 or 5 sec	No	Yes	35mm or longer
	105 (feet)	(26–2.3 ft)						To 28mm with wide-angle diffuser
Auto Electroflash 128	28 (meters)	5–0.7 m	f/5.6	with adjustable head	8, 7, or 4 sec	No	Yes	35mm or longer
	92 (feet)	(16–2.3 ft)						To 28mm with wide-angle diffuser
Auto Electroflash 25	25 (meters)	4.5–0.7 m	f/5.6	—	7 or 6 sec	No	No	35mm or longer
	82 (feet)	(15–2.3 ft)						
Electroflash 20	20 (meters	—	—	—	10 sec	No	No	38mm or longer
	66 (feet)							

*Depending on power source and/or subject distance

Minolta close-up equipment

Minolta makes a variety of equipment to help you take close-up shots of flowers, insects, or other small objects. Pages 78–81 tell more about close-up equipment and techniques.

Extension tubes *that fit singly or in combination between the lens and the camera body are made in various sizes. The Extension Tube Set II (shown here) produces magnifications up to about 2X life size, and several tube sets can be combined for even greater magnification. Metering and exposure with this set is not fully automatic, but Minolta also makes Meter-coupled Automatic Extension Tubes that are fully automatic with any meter-coupled lens.*

Close-up lenses *are available from Minolta in three strengths (No. 0, 1, and 2) which can be used singly or in combination to attach to the front of camera lenses from 35mm to 135mm in focal length. They are available in 49mm, 52mm, and 55mm sizes to fit various lens diameters. Optical glass and two-element construction correct chromatic aberration that might otherwise reduce the detail of the image.*

Minolta makes several macro lenses *specifically designed for close-up work. Shown here is the Rokkor-X 50mm f/3.5 MD Macro Lens. It provides a critically sharp picture at any distance between 9 in and infinity, and can produce magnifications up to ½ life size without attachments. The lens plus its adapter will produce magnifications up to life size. This lens has a fully automatic diaphragm that couples with Minolta's through-the-lens metering system.*

The Copy Stand II *provides a rigid camera support when photographing flat or small objects. The camera attaches to a movable arm that can be locked in position at any point on the tube. The baseboard is 17-11/16 x 15¾ in, with a mat that has markings to facilitate centering of the material to be copied.*

The Anglefinder V *permits viewing and focusing while looking at right angles to the camera viewfinder, which is useful for low-angle shots and when using the camera on a copy stand. The eyepiece tube rotates 360° to allow you to view from any position. The device can be focused for individual eyesight, attaches to any Minolta SLR via slotted grooves in the camera eyepiece, and is supplied with its own case.*

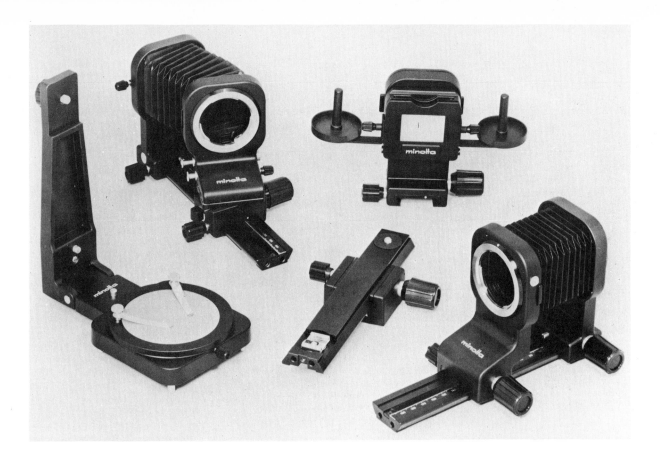

A bellows unit *fits between the lens and the camera body. Shown above are two Minolta bellows plus some of their accessories. Clockwise from lower right: Bellows IV, Focusing Rail, Macro Stand, Auto Bellows III, and Slide Copier.*

Auto Bellows III *is a single-rail unit with dual rack-and-pinion extension controls so that the lens and camera body can be adjusted independently. The unit has a swiveling lens standard which both swings and shifts and is used in situations such as increasing the depth of field by aligning the film plane with the main plane of the subject. The front lens standard reverses, which is often useful in close-up photography. The unit accepts a dual cable release which automatically stops down the lens, then releases the shutter. The Auto Bellows I has many features in common with the Auto Bellows III.*

Bellows IV *is nonautomatic, but offers many of the other features of the Auto Bellows III, including a reversible front lens standard. With this unit, you focus*

with the lens at maximum aperture, but must manually stop down the diaphragm before metering and exposure. Minolta's Bellows III unit has many features in common with the Bellows IV.

The Focusing Rail *attaches to the extension rail of either bellows and secures it to a tripod or to the Macro Stand. With this rail, the entire bellows unit can be moved forward or backward for focusing without having to readjust the camera and/or lens standard separately. The rail has a hot shoe for use with electronic flash.*

The Macro Stand *attaches to the focusing rail for vertical or horizontal use. It has a rotating circular stage with removable retaining clips that can be used to hold a specimen in place.*

The Slide Copier *fits directly onto the extension rail of either bellows unit and accepts 35mm mounted transparencies or strip films. It shifts both horizontally and vertically for cropping and special effects.*

The Magnifier V *aids in precise focusing when making close-ups, copying, or doing telephotography. Its adjustable eyepiece adapts to individual eyesight and magnifies the central portion of the focusing image 2.5 times. It attaches to any Minolta 35mm SLR camera via slotted grooves in the camera eyepiece and is supplied with its own case.*

The Microscope Adapter II *connects any Minolta SLR camera to a microscope. One part attaches to the camera body in place of the lens and the other fits microscope ocular tubes from 23mm to 29mm in diameter.*

Minolta general accessories

Minolta makes a variety of high-quality general accessories for their cameras. See your dealer for these and other Minolta items.

An eveready case *accommodates one camera and lens. It is molded to the camera's shape, and the front of the case drops so it need not be entirely removed to use the camera.*

The Gadget Bag XB-7 *is a luggage-type carrying case that holds an extensive range of equipment. Movable partitions allow for various interior arrangements that can easily hold two camera bodies with lenses attached, a large assortment of other lenses, plus film, filters, flash, and accessories. The top of the bag lifts and the front folds out for easy access to the interior. The case has a wear-resistant black exterior with a black velour interior lining. The bag has both a heavy-duty, adjustable shoulder strap and luggage-type handles.*

The SR Kit Case *is a black, scuff-resistant, satin-finish gadget bag with a red plush interior that holds two SLR bodies plus assorted lenses and accessories; it has a pull-out section that can be completely removed. The exterior features a wide shoulder strap and chrome snap lock.*

Lens cases *protect lenses during travel and/or storage. Fitted hard cases, with adjustable-length straps, are available for 7.5mm to 1600mm lenses. Soft pouch cases, which have no straps, come in various sizes to accommodate lenses up to a 100–200mm zoom.*

The Camera Luggage XDG *case is made of brown, scuff-resistant leatherlike material. The interior foam shell can be cut (the cutting tool is provided) to hold and protect a large variety of equipment. The case has a lockable metal latch and luggage handles for hand carrying plus an adjustable shoulder strap.*

The Professional Tote Bag *is made of a soft, black, scuff-resistant material with the look and feel of leather. The main compartment measures about 5½ in wide by 10½ in long by 10 in tall—large enough to hold a considerable amount of equipment. The main compartment zippers shut as do external compartments at the front and side. The wide shoulder strap is adjustable.*

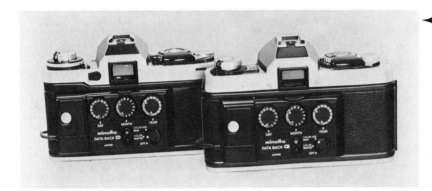

A Data Back *lets you imprint the date or any other coded data on the film frame you are about to expose. This is useful in scientific and technical photography but is also of interest to photographers who simply want to date their pictures for personal purposes. The Data Back D is used with the XD-5 or XD-11; the Data Back G is used with the XG-7 or XG-9. The back replaces the regular removable back cover on these cameras.*

The Rubber Eyepiece Hood VS *is a soft rubber eyecup that fits into slots in the camera's eyepiece. It makes focusing easier by blocking stray light from the eye.*

A lens shade *should be matched to the focal length of the lens. The shorter the focal length, the shallower the shade must be to prevent it intruding into the image. Lens shades are marked with the focal length of the lens they fit.*

A neck strap *attaches to lugs on the camera body. The length is adjustable to suit the user and a nonslip pad aids in secure, comfortable carrying.*

Eyepiece Correction Lenses *provide easier focusing if you are nearsighted or farsighted. They snap into slots in the camera eyepiece and come in nine different diopter strengths: for farsighted vision +0.5, +1, +1.5, +2, and +2.5 diopters; for nearsighted vision -1, -2, -3, and -4 diopters.*

The Tele Holder *aids in steady hand-holding of long telephoto lenses. The support rail telescopes from 16¾ to 28 in. The holder straps onto the shoulder for added support.*

The Panorama Head II *simplifies the making of a panoramic photograph in which a series of images are made to cover a wide horizontal view. The device fits on top of a tripod and then a camera attaches to the top; a built-in spirit level helps in aligning the camera so the horizon line (or other horizontal lines) will be level in each photograph. The head turns in click-stop segments to provide precise side-by-side frames with 28mm, 35mm, 50mm, 85mm, and 100mm lenses. It also has a pan setting for smooth horizontal panning with either still or movie cameras.*

Minolta exposure meters/International offices

Minolta exposure meters

Hand-held meters. Even if you have a camera with a built-in exposure meter, there are times when a separate hand-held meter is useful. There are also some special functions that only a separate meter can perform.

The Auto-Spot II and Auto-Spot II Digital *meters make 1° spot readings for critical measurement of very small areas. As you sight through a viewing window in the meter a silicon photo cell instantly responds to changes in subject brightness and metering information appears in the viewing window (in either model) and on the side of the meter (in the Digital version). Both meters are compact, lightweight, and designed for one-hand operation.*

The Flash Meter III *is a multiple function meter that can measure flash and/or continuously burning light sources. The meter can be set to measure any of the following: reflected or incident light, synchronized electronic flash or M class flash bulbs (with or without ambient light), single-burst electronic flash (with or without ambient light), or the cumulative total of multiple electronic flashes. Accessories are available similar to those for the Auto Meter II. The Flash Meter II has many features in common with the Flash Meter III.*

The Auto Meter II *measures incident light (the light falling on a subject) and instantly displays on a motorized calculator dial the possible shutter speed and aperture combinations. The meter's silicon photo cell and integrated circuitry provide precise and instant readings even in low light. Optional accessories convert the meter for other uses, such as: attachments to read reflected light either from a 10° spot or a wider 40° angle; an enlarger mask that adapts the unit for darkroom use as an on-easel enlarger meter; a miniature probe for readings in small, hard-to-read places; neutral density diffusers for metering very bright light sources.*

A Meter Booster Kit *adds specialized metering functions to the Auto Meter II and Flash Meters II and III. The battery-operated booster plugs into a jack on the meter to increase low-light sensitivity for special applications. Various attachments permit metering from an SLR viewfinder eyepiece, focusing screen, view camera ground glass, 35mm film plane, and microscope eyepiece.*

▶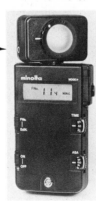

U.S. regional offices

Minolta Corporation
101 Williams Drive
Ramsey, New Jersey 07446

Minolta Corporation
3105 Lomita Boulevard
Torrance, California 90505

Minolta Corporation
5904 Peachtree Corners, East
Norcross, Georgia 30071

Minolta Corporation
3000 Tollview Drive
Rolling Meadows, Illinois 60008

International offices

Minolta Camera Co., Ltd.
30, 2-chome, Azuchi-machi, Higashi-ku
Osaka 541, Japan

Minolta Camera (Canada) Inc.
1344 Fewster Drive
Mississauga, Ontario L4W, 1A4
Canada

Minolta Camera Handelsgesellschaft
m.b.H.
Kurt-Fischer-Strasse 50
D-2070 Ahrensburg
West Germany

Minolta France S.A.
357 bis,
rue d'Estienne d'Orves 92700 Colombes
France

Minolta Nederland B.V.
Groen van Prinstererlaan 114
Amstelveen, Nederland

Minolta Vertriebsgesellschaft m.b.H.
Seidengasse 19, A-1072
Wien, Austria

Minolta Hong Kong Limited
49 Chatham Road
Kowloon, Hong Kong

Minolta Singapore (Pte) Ltd.
Chin Swee Tower, 52-E
Chin Swee Road
Singapore 3

Index